Harald Francke - Canon EOS 10

Canon
EOS 10

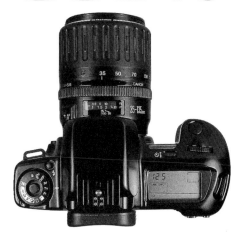

in U.S.A.

Canon
EOS
10s

Harald Francke

HOVE FOTO BOOKS

In U.S.A.
the EOS10 is known as the
EOS 10s

All text, illustrations and data apply to cameras with either name

First English Edition November 1990
Reprinted March 1992
Published by Hove Foto Books
34 Church Road, Hove, Sussex BN3 2GJ

English Translation: Meckie Hellary
Technical Editor: George Wakefield
Production: Georgina Fuller
Typesetting and Layout: ADT, Hove, BN3 1NA
Printed in Germany by Kosel GmbH, Kempten

British Library Cataloguing in Publication Data
Francke, Harald
 Canon EOS 10.
 1. 35mm cameras. Techniques
 I. Title
 771.32

 ISBN 0-906447-65-8

UK Distribution

Book Trade:
Fountain Press Ltd.
Queensborough House
Claremont Road
Surbiton, Surrey
KT6 4QU

Photo Trade:
Newpro (UK) Ltd.
Old Sawmills Road
Faringdon, Oxon
SN7 7DS10

CONTENTS

The Body - A Little Outside, A Lot Inside

A camera offering such a lot of features should still remain clear and simple. The Canon EOS 10 proves that a complexity of features and ease of use can still be faces of the same coin.

Since the advent of the Canon T90 we have become used to the central input dial on Canon single lens reflex cameras, which lies within the reach of the right index finger. This dial is used to alter the values within the various operating modes and specific basic settings.

There are eleven different operating modes which are selected with a second command dial to the left of the viewfinder eyepiece. In the **L** position the dial is locked and the camera switched off. To use the automatic features press the command button and turn the dial clockwise.

The automatic programming features available are program mode with shift (**P**), shutter priority mode (**Tv**), aperture priority mode (**Av**), depth of field mode (**DEP**), camera-shake alert (camera symbol) and manual exposure control mode (**M**).

If you prefer to shoot with a fully-automatic EOS 10 take the main switch out of the **L** position by turning it anticlockwise.

Now you can choose between an automatic program based on focal length and four image-based programs designed for portrait, landscape, close-up and sports.

Turn the dial to the next position for the bar code program, which is a rather special feature. Precise adjustments can be made for specific subjects

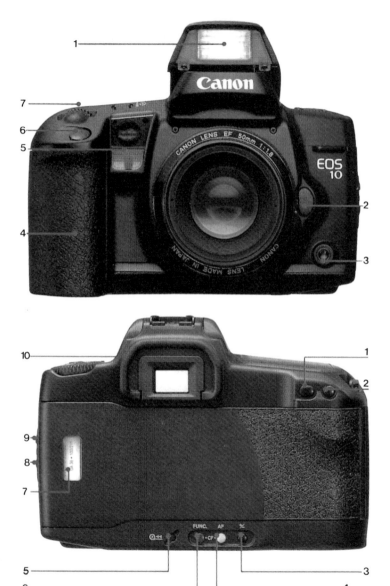

Canon EOS 10 - front (above): 1 Built-in flash in operating position
2 Lens release **3** Bar code receptor **4** Handgrip **5** AF Auxiliary Light
Emitter/Self-timer & Remote Control Indicator **6** Shutter release button
7 Electronic input dial
Canon EOS 10 - back (below): 1 Focus mark button **2** Partial metering
button **3** exposure compensation button **4** AF mode button **5** film rewind
button

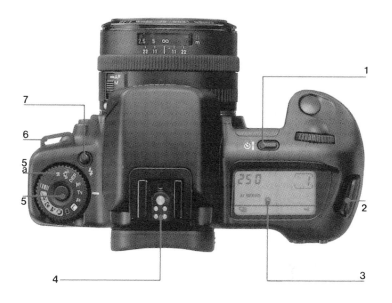

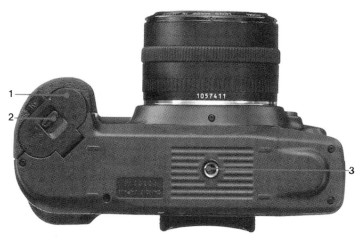

6 Function button (with button 4 for Custom Functions) 7 film check window 8 back cover lock button 9 back cover latch 10 viewfinder eyepiece
Canon EOS 10 - from above: 1 Self-timer/Remote control button **2** Strap lug **3** LCD panel **4** Accessory shoe **5** Release button for **5a** Command dial **6** Strap lug **7** Flash button
Canon EOS 10 - from below: 1 battery cover **2** Battery cover lock **3** Tripod socket

illustrated and described in a special bar code book. It works by using this booklet and a special bar code reader. Old hands might dismiss this feature as a gimmick but the beginner will most likely be relieved to see their problem subject depicted in the booklet enabling them to program their EOS 10 accordingly. The settings to the left of the **L** are marked by icons and I will refer to them as "icon programs" from now on.

Apart from these two dials there are five other buttons to set up the EOS 10 with certain features. Three of these buttons are located at the bottom rear of the camera, the fourth and fifth are within reach of your right thumb. The position of these buttons was determined by the frequency with which they are used

By simply touching the blue button at the bottom, several basic functions can be selected; film transport, manual film speed setting, multiple exposure, automatic exposure bracketing, interval timer, audible signal. Having preselected the functions certain values can now be set by simply turning the input dial. A positive point is that the blue button need not be held down when operating the input dial. After a period of about 6 seconds, however, the EOS 10 will automatically revert to the preselected function.

By pressing the yellow button you can then select the one-shot autofocus mode or the AI servo autofocus mode.

You will be able to customise your EOS 10 in 14 functions according to your own requirements by pressing both the blue and yellow buttons simultaneously (15 functions when using a Canon EOS 10 with data back, not available in this country at present). It is actually not important to press both buttons at exactly the same time, just hold them down together for a moment. Which button is pressed first is not important, either. The fact that the 14 custom

functions are not identified by name or symbol might be a little irritating at first but after some experimenting you will soon have created an individual EOS 10 for the pictures you have in mind. As you will not make any more alterations from now on any explanatory symbols would only be in the way.

The third button in the row is black like the camera itself and activates the exposure compensation function. Using the input dial you can now select aperture values from +5 to -5 in half-stop increments. Although the correct selection of the basic functions is important for the picture, you are unlikely to alter it for each shot. Once set, the basic functions will remain for some time. The position of the buttons at the bottom of the body does not therefore create real problems. On the contrary, it is quite impossible to change some settings inadvertantly.

The other two buttons which are important when taking a photograph with your EOS 10 are located where they can be reached easily with your right thumb. The smaller button on the right activates the partial metering function. Having selected the corresponding user function the lens is stopped down simultaneously and you can check the focus distribution in the picture.

When operating the larger button on the left, the LCD panel will show three small boxes and in the viewfinder three red-lined focus marks will appear. Using the input dial again you can now decide whether one of the three boxes should be selected automatically or whether only one of the boxes should function as the AF target. As the decision for selective metering or for a particular focus mark often has to be taken very quickly the location of these buttons at the top right seems eminently practical.

That leaves four further buttons on the EOS 10 body to be mentioned. The shutter release button in front of

the input dial works in two ways. When the camera is switched on, lightly touching this button will activate all the meter systems and indicators. Pressing the button right down operates all the functions required for the exposure.

To the left of the input dial you will find a slim button which represents the self-timer and remote control for exposing pictures 10 seconds after the shutter has been released. While the function is running, a red indicator light can be seen underneath the button and, depending on the preselection, an audible signal can be heard.

To the left of the viewfinder head is a small button marked with a flash symbol. It activates the built-in flash (not on the icon program). It is switched off by pressing the button a second time.

The remaining larger button to the left of the lens releases the lens from the camera.

The LCD Panel - All You Need to Know

Although the camera's operation is almost fully automatic the photographer should still know what the camera is doing. The Canon EOS 10 provides two information centres.

The Canon EOS 10's most important information centre is the LED panel at the bottom of the viewfinder image. It provides all the relevant information for shooting the picture - without the need to remove the camera from the eye.

The most important values are shutter speed and aperture which are displayed for all exposure control variations - except for the B setting. Here you will find the word "bulb" in place of the shutter speed. The fast shutter speeds are displayed as whole numbers - "125" stands for 1/125 sec. Speeds slower than 1 sec are displayed by the (") symbol. If you traded in an older camera for the EOS 10 you should not worry about the odd values for speed and aperture. The EOS 10 displays these values in half-stop increments like the manual settings. Although the automatic speed and aperture control is infinitely variable the exact display of settings would only be confusing.

The second important display within the viewfinder is a green dot which lights up when the subject is in focus - including manual focusing - and it blinks when the AF system cannot focus properly - excluding manual focusing.

Apart from these three displays which are always visible the viewfinder information includes (from left to

right):

- the camera-shake alert symbol in the respective program,
- the "*" symbol storing the measured or selected AE values,

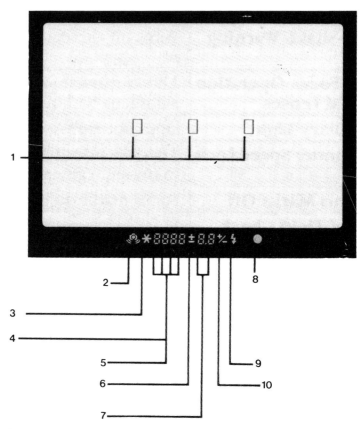

Viewfinder display: 1 Focus marks **2** Camera-shake alert **3** AE lock
4 Shutter speed **5** Depth of field AE indicator **6** Manual exposure
7 Aperture value **8** AF in-focus **9** Flash-ready **10** Exposure compensation

- the symbols "dEP", "dEP1" or "dEP2", when depth of field mode is used, in place of the shutter speed,

- "+" and/or "-" symbol as setting aid for manual exposure control,

- a "+/-" symbol indicating that you are using exposure compensation factors and warning you not to use exposure compensation where it is not needed,

- a flash symbol informing you that the built-in flash or a system flash unit is charged and ready.

The LCD panel at the right-hand top of the body gives you even more information. The illustration shows the display in detail. To make identification easier the functional settings in the bottom row are separated by a blue line, the AF settings by a yellow frame. The **FUNC** and **AF** buttons are therefore coloured blue and yellow respectively.

You can imagine the chaos if all the data - 42 altogether - were displayed at the same time. With that in mind Canon decided to indicate in the display only the information currently necessary.

Example 1: You want to check or change the film speed setting and select that function with the blue **FUNC** button. The display on the panel disappears completely and only the **ISO** symbol with its corresponding number appears instead.

Example 2: With the **CF** buttons you have programmed your EOS 10 to leave the film leader outside the cassette. You now want to use the interval timer with a preselected aperture of f/5.6. You decide that you want a slightly longer exposure and set a compensation factor of +0.5. You find the AF function "One-shot" suitable. The panel will now display "5.6" for the preselected aperture, a figure between "1" and "36" for the picture number, "One-shot" for the AF function, "CF" indicating that custom functions have been selected, "+/-" indicating the compensation factor and finally the icon of a film cassette showing that a film has

been loaded. Underneath the blue line one or more squares indicate whether the film wind mode is set for single or multiple frame. Here you also find the audible signal icon if you select this function. As soon as you touch the shutter button the automatically selected shutter speed will appear beside the preselected aperture. The indicator will blink if the fastest shutter speed is too slow for a very light subject. The slowest shutter speed will blink if it is too fast for a very dark subject.

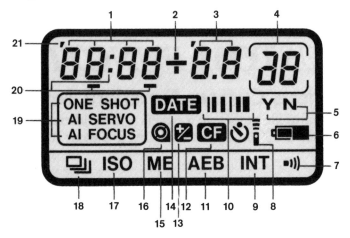

The LCD panel: This diagram shows all the displays available but they never appear all at once.
1 Shutter speed / film speed / depth of field (function) / interval timer / bar code program number **2** Exposure compensation (function) **3** Aperture / exposure compensation (value) / auto exposure bracketing (value) / depth of field (function) / interval timer (value) / battery check **4** Bar code program / number of multiple exposures / Custom Function control number / interval timer frame number **5** Custom Function on/off / Custom Function on/off / camera-shake audible signal on/off **6** Battery check **7** Camera-shake alert **8** Self-timer or remote controller (function) **9** Interval timer **10** Bar code program (function) **11** Auto exposure bracketing **12** Custom Function (set) **13** Exposure compensation (function) **14** (only with EOS 10 QD) **15** Multiple exposure **16** Film-load check/Film Rewind completion **17** Film speed setting **18** Film winding mode **19 & 20** (only with EOS 10 QD)

The LCD panel will also show the battery icon at the bottom right-hand corner every time you turn the command dial away from the **L** position. If the icon shows a half-full battery you know that you need to have a new battery ready. If the battery check icon is flashing you know that only a few exposures are left. If after changing the battery "bc" appears on the panel the battery is inserted incorrectly.

Design - Compact and Easy to Use

Since the star designer Luigi Colani became involved in camera design, and the Canon T90 was developed following his ideas, there is no need for cameras to look like a box with square edges and corners. The influence of Luigi Colani is still visible in the Canon EOS 10.

Colani's major principle was to combine good design with ease of use. And as pioneered by the Canon T90 the soft form of the Canon EOS 10 is also extremely comfortable to hold. The special finish of the body ensures a good grip even in hot countries where your hands can become damp.

The camera is very well designed; information and current controls at the top right and preselecting controls at the top left and bottom rear of the body.

Wide-angle and standard lenses are the best choice for landscape photography. A "heavy" foreground balances the rather pale sky. It is quite possible to frame the landscape without any sky at all.

These controls are described in detail in a later chapters.

There is not much more that needs mentioning on the Canon EOS 10; the slide button to open the camera back is well protected from accidental opening as is the button to start mid-film rewind. The button disengaging the lens from the camera is generously large - the advantage of which you will appreciate the first time you change the lens wearing gloves. The button for self-timer and IR remote control on the other hand is perhaps a little small. Since on the whole these functions are used less often it should really create no great problems.

More obvious perhaps is the transparent red plastic panel between grip and lens. This is the AF Auxiliary LED/self-timer and remote control indicator.

Loading the film is not a problem either with a camera like the EOS 10. The cassette is simply placed in its recess, the film is pulled up to the red marker and the back is closed. Everything else the camera does automatically.

The small crater at the bottom right hand corner (seen from the front) is something special, however. This is the barcode receptor where the bar code reader is docked after taking the relevant subject information from the bar code booklet.

Close-up shots bring some variety into a slide show. Colour photography need not necessarily mean a lot of colours in the picture, as shown in the illustration above. On the other hand, restraint in the use of colour is not imperative, as the snapshot below shows.

Preparation - Setting Up

Generally speaking the camera is ready for use as soon as it has been taken from its packaging. But there are a few points to be considered before taking your first picture.

The Canon EOS 10 is a very comfortable camera to hold especially with its well-designed grip. If, however, Mother Nature gave you a rather large pair of hands you may find this grip a little on the small side. This is no problem as there is a grip extension GR-60 available which is screwed into the tripod fixture. The grip extension's great advantage lies in its adjustable carrying loop. Wandering through narrow lanes of a holiday village holding a camera ready to shoot in your hand could become quite tiring without a carrying loop. The camera can be carried comfortably for hours held by this loop.

The compartment for the 6v lithium battery is situated inside the EOS 10's grip. The first battery is included with the camera and only needs to be inserted. If you have used SLR cameras in the past you will be pleased to find that no coin, spoon handle or pen-knife is required to open this battery cover! One thing remains the same, however; it is still possible to insert the battery the wrong way round and wonder why the camera fails to work. So please remember; the two silver-coloured contacts are at the top and must go in first.

Any further batteries you will have to buy yourself and you will soon find that they are not cheap. You will

also notice that the first battery needs to be replaced quite soon. This is not because the Canon EOS 10 seems to gobble up a lot of energy, the reason lying rather in the enthusiastic use when you first own your EOS 10. Obviously you want to get to know all its functions and present your new toy to family and friends, which naturally uses at lot of power. Among other things, the battery has to power the exposure meter, the autofocus system, the film transport as well as the automatic focusing motor within the lens.

The life of the battery is difficult to predict. Although the LCD panel warns of the battery state it is advisable to take a spare when indulging in a lot of shooting on holiday, for example. Being a lithium battery it should not weaken noticeably during storage like an alkaline battery.

The Custom Functions - A Camera for the Individual

The user-friendly technical innovations of the past few years included the facility to customise a camera for individual interests and preferences by means of various functions. This facility has been greatly extended in the case of the Canon EOS 10.

The two buttons activating these Custom Functions are marked **CF** and are located at the bottom rear of your EOS 10. Having pressed these buttons for the first time you notice that the LCD panel indicates "CF", the figure "1" for the first user function and an "N" indicating that the first user function is not switched on. Turning the input dial you see the numbers for the different custom functions appear one after the other. The "N" remains as none of them is switched on yet. With the input dial, select the number for the user function you want to activate and press the partial metering button. The "N" for "No" will disappear and a "Y" for "Yes" will appear. Now the user function is switched on. All the functions you want can be activated or changed in one operation. By pressing the shutter button the alterations as they are now, are stored in the camera even when your EOS 10 is switched off.

It obviously makes sense to activate only those functions you actually need. To alter the basic setting just for the sake of it might be fun but there really is no photographic advantage.

The custom functions and their practical effects are detailed as follows:

Custom Function 1: Switching off the automatic film rewind.

Under normal conditions the EOS 10 knows when the last frame of a film has been exposed and automatically activates the film rewind motor. Useful as this might be, the noise it makes during rewind can be irritating. Especially in quiet situations like weddings or christenings in church, in the theatre or concert hall, the motor's whirring sound can be quite annoying. Although it is impossible to rewind the film by hand without making any noise, by pressing a button you can at least decide when the rewinding mechanism should operate again.

Custom Function 2: Leaving the film leader outside the cassette when using the automatic film rewind.

A great advantage of rewinding the film completely into its cassette is that you cannot expose the same film twice.

The large processing laboratories also prefer to receive a completely rewound film as contrary to popular belief the film is not pulled out through the slit for developing because scratches and flashing through static electricity could occur. Therefore the cartridge is cracked open to remove the film.

If you develop your Kodak T-Max films yourself by

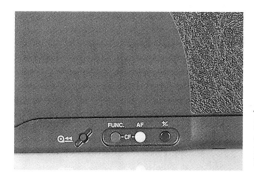

The Custom Functions can be set once the AF and FUNC buttons have been pressed.

all means select Function 2 if you have the time to wipe the cartridge mouth and slowly pull out the film.

Custom Function 2 is also useful when a partly-exposed film needs to be rewound to be used again later, in the case of Kodachrome 25 for example, when the film has not been used up during the day and Kodachrome 200 is required for shooting at dusk.

Note: if the film is not fully rewound the leader will lie on the shutter. Don't touch it to avoid damaging shutter operation.

Custom Function 3: Manual setting of film speed.

The automatic reading of the film speed of DX-coded cassettes is a real blessing, especially for photographers frequently using films of different speeds. On holiday you might want to use Ektachrome 50 HC to take rich colour slides with minimum grain for shooting the picturesque old town while in the evening you want to capture the atmosphere of that cheap little restaurant by the harbour with Kodacolor Gold 200.

If you have a favourite film, however, where you use an aperture a third-stop smaller because you prefer those richer colours on the slide, DX-coding could be a nuisance. Without Function 3, to be able to use a slower exposure you would need to set the ISO number for every new film. Using the compensation factors would not really be possible, either, as they are only available in 1/2 stop increments. But by switching on Function 3 your manually-set ISO value is stored until you change it or you switch this function off again.

Custom Function 4: Initiates the autofocus function by pressing the partial metering button.

Provided the EOS 10 camera has been switched on, pressing the shutter button half-way down activates the

metering and control systems for shutter speed and/or aperture giving a correctly exposed picture.

At the same time the lens is focused. This procedure can also be started by pressing the partial metering button after selecting Custom Function 4. This involves the simultaneous storing of the metering values as well. It makes sense therefore to select the central AF section. Then, under difficult or unusual conditions - where you want the main subject to be in a corner of the picture for instance - the focus and exposure values can be selected with your thumb, leaving the index finger free to alter shutter speed and aperture easily within the stored exposure value by using the input dial.

Important: Storing of focus values will not work in the AF mode "AI Servo".

Custom Function 5: Manual aperture setting using input dial.

Despite all its automatic functions the Canon EOS 10 also allows aperture and shutter speed to be set manually. You use the exposure meter to achieve the same result an automatic exposure can reach more easily. It makes more sense to set speed and aperture manually for special effects only or to master difficult situations from past experience. The basic setting allows the shutter speed to be altered by using the input dial. It also allows the aperture to be controlled by pressing the partial metering button. This procedure is perhaps a little complicated. By using Custom Function 5 the allocation of setting elements is reversed: the input dial controls the aperture, input dial plus partial metering button control the shutter speed.

Such a change might not be necessary for many manually-controlled situations but under certain conditions it could prove quite useful.

Especially when using an older type of flash unit

without TTL control, the setting of the flash aperture via the input dial is much easier than having to press the partial metering button as well.

This also applies to studio flash units, particularly for multiple exposures. Although it is possible to combine the AEB function with the manual setting of aperture and shutter speed the sequence of three exposures is actually too fast for flash photography. Use Custom Function 5 in that case, alter the aperture slightly by means of the input dial, wait until the flash unit is ready again and shoot.

Custom Function 6: Turning off the automatic camera-shake warning tone.

The Canon EOS 10 warns you of camera shake by an audible signal, which when using the simpler types of exposure control can be switched off with the **FUNC** button. If you select one of the more complex programs, however, this signal cannot be switched off with the **FUNC** button and your EOS 10 will warn you again of camera shake. In the green zone and the portrait and macro programs the tone can be heard until the built-in flash has been switched on, which is long enough. It can be particularly annoying when the landscape or sports programs have been selected or when you are supporting the camera on a tripod, say, and it signals as soon as the shutter speed falls below

The partial metering button is converted by means of a Custom Function either into a depth of field preview or autofocus button.

the hand-held level. Using Custom Function 6 your EOS 10 can also be silenced in the selective program mode.

Custom Function 7: Manual refocusing of USM lenses.

A special role in Canon's range of lenses for EOS cameras is played by the sophisticated USM lenses where an ultrasonic motor controls the AF performance. The manual focusing rings of the first generation USM lenses were uncoupled when the lens was set for autofocus. In selecting Custom Function 7 you ensure that the focusing rings of these older USM lenses, despite autofocus, remain coupled to the required groups of elements and that after automatic focusing you can refocus manually straight away without further switching. The second generation of USM lenses introduced together with the EOS 10 (35-105, 70-210 and 100-300mm) do not require Custom Function 7 as they can be prefocused either by ultrasonic motor or by hand.

At first glance the manual focusing facility does not seem to warrant its own Custom Function in an AF camera just for the sake of speed and ease as manual refocusing is indeed rarely necessary. But it might just be possible - shooting action for example - that the AF points suddenly hit a low-contrast white sports shirt making automatic focusing impossible. Then the option of getting a sharp picture by simply turning the focusing ring is worth its weight in gold, particularly when two of the three AF fields focus on the wrong object and the sharpness needs to be corrected quickly.

Manual refocusing is only appropriate in connection with the ONE SHOT mode as the automatic focus always operates in the AI-SERVO mode and deviation from the definition set in the AF areas would cause a reaction.

Custom Function 8: Switching off the AF auxiliary light.

The EOS 10 automatically emits an AF auxiliary light when conditions are too dark for automatic focusing. The red plastic-covered light is located underneath the self-timer button and it projects a pattern of light and dark beams on to the subject as reference points for autofocus. Switching this AF auxiliary light off using Custom Function 8 is seldom necessary as with it a sharp picture can still be shot where conditions would otherwise be impossible without it. On the other hand there might be a situation where the red light comes up at dusk although with the naked eye the sharpness is visible on the focusing screen and it could be set manually. If you are taking portraits under such conditions it might be preferable to switch of the auxiliary light as its brightness could irritate the subject.

The AF auxiliary light should also be switched off when one of the big high-speed telephoto lenses is used. As the light is located so near the optical axis, i.e. near the bayonet fitting, it would illuminate the tube of the EF 300mm,f/2.8L for example.

Custom Function 9: Locking the shutter speed at 1/125 sec when using flash with aperture priority AE.

One great advantage of Canon's TTL flash control is the perfect balance of the light emitted from the flash and the surrounding brightness.

In the context of aperture priority AE you preselect an aperture, the light from the flash passing through the aperture is metered and the flash is switched off as soon as the correct amount of light is reached. At the same time the shutter speed is set in such a way that the sourrounding brightness is sufficient for the correct exposure of the film, i.e. the flash exposes the main subject correctly and the ambient light looks after

For ordinary pictures the display of the active focus field in the viewfinder is not required. The focus mark lights can be switched off with Custom Function 10.

the background. As the flash is normally used in conditions of low light the shutter speeds set often require a tripod.

If you prefer not to use a tripod and accept that the correctly exposed main subject will appear against a dark background you should select Custom Function 9. The camera thereby automatically sets a synchronising speed of 1/125 sec as soon as the flash is ready. You will now be able to control the focusing zone of a flash exposure via the aperture without causing camera-shake.

Custom Function 10: Switching off the red focus marks.

The EOS 10 will inform you of the particular focus field focusing on certain subject parts. The fields concerned are framed in red, which, of course, also occurs when only one focus field is required. The red

markers are certainly necessary if you want to leave the decision of the choice of focus field to the camera. But if you have specified the focus field beforehand, the red markers are quite unnecessary or even irritating. That is where you use Custom Function 10 as the red focus mark(s) will not appear until you select another program. The red markers will also be visible when redistributing the active focus fields despite Custom Function 10 being switched on. This is quite useful when you want to make alterations without taking the camera away from the eye.

Note: The red focus marks are not shown during the SPORTS program.

Custom Function 11: The partial metering button becomes the depth of field preview button.

At first a depth of field preview button might seem unnecessary for a camera like the EOS 10 with a built-in automatic depth of field mode. But this automatic function is a useful addition to the various automatic exposure modes, although it is really an automatic timer selecting the correct aperture for the desired depth of field zone. If you select a shutter speed and want to check the depth of field zone use Custom Fuction 11 as you cannot do so using the **DEP** setting. Having selected Function 11 press the partial metering button whereby the camera automatically selects the best exposure values. In the darker areas of the viewfinder you can see quite clearly which parts of the subject will be sharp and which will be out of focus. If you now press the shutter button nothing will happen. You can only take a picture if, before using the partial metering button for the first time, you have pressed the shutter button half-way to check the focus. This can be avoided by selecting Custom Function 4 as well. Prior to shooting, the autofocus, partial metering and aperture value functions are now fixed to the partial

metering button.

As long as AF mode ONE SHOT is set, the combination of Custom Functions 4 and 11 will not create any problems. In the AF mode AI SERVO, however, the depth of field preview program is not possible.

Important: Custom Function 11 is ineffective with the special programs.

Custom Function 12: Storing evaluative metering values with the partial metering button.

If you point the unaltered EOS 10 at the subject and pressed the shutter button half-way in AF mode ONE SHOT, the values for depth of focus and evaluative metering are set and stored until the shutter is released fully. Pressing the partial metering button afterwards will store the partial metering value together with the depth of focus value until shooting.

In the AF mode AI SERVO, neither exposure nor depth of focus can be stored. The camera automatically meters and resets until the shutter is released fully. When the partial metering button is used the partial metering value is stored but the depth of focus continues to be set until the shutter is released. This means in effect that you cannot store the evaluative metering independently of the depth of focus value which is only possible with Custom Function 12 and selecting AF mode ONE SHOT. The partial metering button becomes the evaluative metering button which, when pressed, stores the value determined by 8-zone evaluative metering (with all its options of emphasising the centre, left or right of the picture). The depth of focus can be stored separately by pressing the shutter release half-way.

Custom Function 12 still allows the values for depth of focus and evaluative metering to be stored simultanously, but partial metering is not possible.

The partial metering button is inoperative in the Custom programs whether Custom Function 12 is set or not.

Custom Function 13: Using mirror-up function.

The mirror-up function is seldom required but is very important. Whenever there is danger of camera-shake, e.g. close-up situations and exposures with very long focal lengths, the vibration caused by the mirror popping up can affect the picture. In such cases one is often advised to use the self-timer but this would require the mirror to pop up immediately after shutter release. Then all vibration will have ceased by the time the exposure is concluded. If you check the self-timer of your EOS 10 you will find that the mirror only pops up immediately before exposure. To alter this just select Custom Function 13 and the mirror will pop up immediately after shutter release. This eliminates any camera-shake during the 10 sec until exposure. But you must use a tripod as without a firm support the mirror-up function is a waste of time. Tripods like the Cullmann Magic 2 or Cullmann Clamp are so neat and light that you should not fail to shoot the perfect picture for the lack of a tripod.

Custom Function 14: Cancellation of speed-limit function in camera-shake alert mode.

The rule of thumb "Slowest shutter speed for hand-held pictures = one divided by focal length in mm" tells you up to which shutter speed an average photographer can hold the camera steady without blurring the picture. The camera-shake alert function of the EOS 10 is based on this general rule. Knowing the focal length of the lens the camera locks the shutter when the shutter speed is slower than the rule of thumb permits so there is no chance of a blurred result. Signals within the viewfinder warn of a shutter

Light not very bright and about 200mm setting for focal length - try using camera-shake alert and Custom Function 14.

speed one or two steps slower than the rule of thumb or whether speeds more than two steps beyond the hand-held limit are needed.

If you like to have this information but prefer not to be told by the camera whether you can use the shutter or not, select Custom Function 14. The speed limit of faster than or equal to "One divided by focal length" is cancelled and you can use slower shutter speeds as well.

Custom Function 15: Including date and time in the picture.

Inclusion of date and time is only possible with the Canon EOS 10 QD which is not available on the European market. These cameras normally allow either the date or the time to be included in the picture. With Custom Function 15 both can be included simultanously.

Custom Function 16: Turning off the automatic focus confirmation tone.

When the lens is focused, a green dot in the viewfinder and an audible signal confirms the function. The audible signal is only useful when you are not looking through the viewfinder. As this is only very rarely the case you might want to switch off the audible signal. There is no special Custom Function for this. However, simply press the blue **FUNC** button until the ultrasonic selection appears together with a "Y" on the LCD panel. By turning the input dial the "Y" will disappear and a "N" is shown instead. But this signal will again be heard when one of the selective programs has been chosen.

Film Choice - Decisions, Decisions

Although electronic picture recording cameras are now a reality they are still regarded as outsiders when it comes to converting good ideas into good pictures. For a conventional film is - and will probably be for many years to come - still your best bet. The tremendous choice of films on the market can be confusing but selection becomes easy when you know the principles before going into detail.

Up until 1936 photography was basically black and white. Although colour pictures were possible, taking them was simply too complicated for the average photographer. This changed when Kodak and Agfa almost simultaneously brought out the first subtractive colour films. The advance of colour was slow at first but could not be halted. And the majority of films bought today are colour films with colour negative films the most popular. Modern colour negative films like those from the Kodacolor Gold series are able to cope very well with underexposure up to one stop and overexposure up to two stops and manage even larger discrepancies by only marginally reducing the quality. The grain is so fine that even big enlargements like posters come out well - provided a good lens was used, which can, of course be expected with the EOS 10.

If you prefer an even finer grain, try a film like those from the Kodak Ektar range. These films have been developed to the highest standards of sharpness and fineness of grain. But they do require more precise exposure than the Gold films, which again is no

problem for the Canon EOS 10.

Colour negative film is usually sent to a laboratory for developing and printing. Of course, you can always process the films yourself. There are plenty of excellent chemicals, developing aids and laboratory equipment available for home use. The Jobo and Tetenal companies together have developed a laboratory kit containing all you need - equipment by Jobo, processing chemicals by Tetenal.

Using black and white films is a different story however. Very few commercial laboratories accept these films nowadays, especially at a reasonable price. Processing black and white films yourself is practically the only solution. Despite these films having fallen in popularity, the quality is as high as ever or even better - take the Kodak T-Max series, for example.

Processing and printing black and white films yourself is not a great problem as long as your home has a room which can be darkened for a few hours and barred to other people. The most expensive part of your equipment will be the enlarger. Choose one that can be extended for colour use, if necessary. The Kaiser company carries a good selection in its V-series. You will also need vessels for developing the films, dishes for the paper, bottles for the chemicals, graduated cylinders, print tongs and thermometers. Have a look through the Hama accessory catalogue.

Not only is processing your own black and white film a necessity in most cases, it can be highly pleasurable, too. In your own laboratory you can use all sorts of tricks to turn a good frame into an stunning black and white picture.

There is one exception, however, where a black and white film can be developed in most commercial labs. This is Ilford XP-1, basically a chromogenic film and processed as a colour film in C-41 chemicals.

The easiest film to process from your point of view is

colour transparency film. After exposure you simply return it to the makers or hand it to an E-6 laboratory. One exception are the Kodachrome films which must be returned to a Kodak laboratory. These films have a different composition which gives an extremely fine-grained picture. The advantage of a Kodachrome film is reduced somewhat, however, by the arrival of new emulsions like Ektachrome 50 HC, for example.

Whereas with a negative film you have to wait until the picture is printed, you can see a transparency film in the form of slides immediately after processing. The values of brightness and colour, reversed in the negative, are correct from the start on a slide film. You can certainly view a slide by holding it against the light between thumb and forefinger, but to appreciate fully the brilliant colours of Ektachrome 100 or Kodachrome 200 you really need a slide projector and a good projection screen. What can compare to the brilliant picture thrown 150 or 200cm wide on a screen? Only direct slide prints on Ilford Cibachrome paper, perhaps. But even these cannot fully equal the effect of a projected slide.

Standard black and white and colour negative films as well as colour transparency films form the basis of an extensive range of 35mm materials.

Also available are a number of specialist films that could be of interest to the amateur, too. Infrared films like Kodak Ektachrome Infrared are also called false-colour films as they render colour differently from its true nature. It is quite impossible to predict the colours exactly as the proportion of infrared in the light changes with the position of sun and clouds. Using coloured filters changes the colours again and there is no limit to experimenting.

Black and white infrared films (Kodak High Speed Infrared Film 2481) require a red filter (Kodak Wratten No. 25, No. 29 or No. 70 or similar e.g. Cokin) or a

special infrared filter (Kodak Wratten No. 87, No. 87 C or No. 88 A). These films show the sky as black and green plants almost white in daylight photography. Incidentally, to use such black and white infrared films you need to switch your EOS 10 to manual focusing and go by the IR index provided in the distance scales on Canon EF lenses.

While infrared films are probably rarely required, the use of tungsten films should be much wider spread. These films are designed for indoor photography with photographic lighting (not flash sources as they simulate daylight). They reproduce the true colours whereas a daylight film under these lights will produce a yellow tint to your pictures. Ordinary household light bulbs create a strong yellowish-orange cast on daylight films, but a soft yellowing on tungsten film which can be rather attractive and should not be filtered out.

It is worth experimenting with against-the-light photography. The built-in flash of the EOS 10 plus A-TTL flash control give a balanced result. With the flash switched off and the sky acting as exposure point the flowers are reduced to silhouettes.

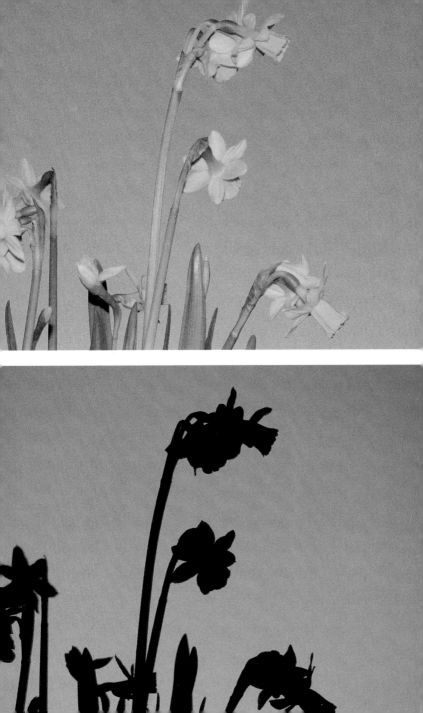

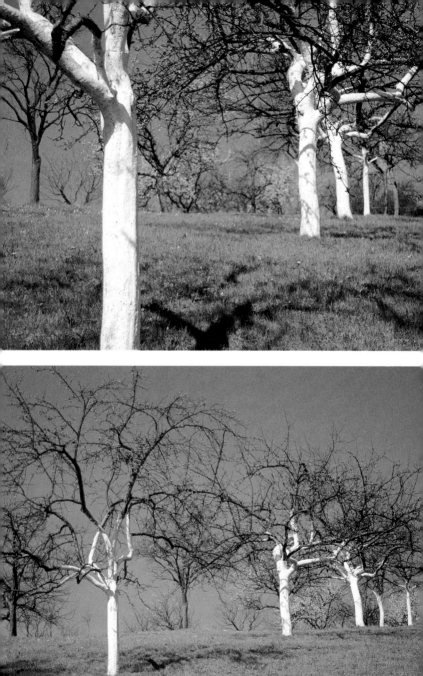

A third group of specialist films could be of interest to the amateur - the duplicating films. Available in the 35-mm range is, for example, the Kodak Ektachrome SE Duplicating Film SO-366 which is best used with a flash unit like the Multiflash Colour Slide Duplicator. Several adjustment tests are necessary, however, based on the filtration indicated in the film information data. They are perhaps not justified for the occasional inclusion of frame dissolves in a slide show. But if you frequently participate in photographic competitions the rather complicated use of SO-366 film could bring rewards.

Foreground and background are equally captured by the depth of field mode and autofocus of the EOS 10. the diagonal gives a sense of depth. The multiple zone AE can handle even a large and bright area of sky very well. The difference between the "flat" tele perspective (above) and the "steep" wide-angle perspective (below) is emphasized by a change of position.

Film Speeds - Bright Light or No Light at All

Buying a film not only requires a choice between black and white, colour or transparency films but also the consideration of film speed and whether it should be of the amateur or professional range of films.

The indication of film speed represents the amount of light needed to record a picture. The current range of films can therefore be divided into four groups: slow, medium, high-speed and ultra-speed films. Those films regarded as slow today have speeds of ISO 25/15°, ISO 50/18° and ISO 64/19° and used to be classified as normal speed under the ASA system. Today the old ASA and DIN values have been combined in the ISO system with the ASA value before the oblique stroke and the DIN value with the degree after it.

Slow films are available as negative film (Kodak Ektar 25) and as transparency film for E-6 processing (Kodak Ektachrome 50 HC) and K-14 processing (Kodachrome 25 and 64). They are extremely fine-grained and of exceptional sharpness and therefore suitable whenever high definition and maximum resolving power are important. Choose them for macro photography to record minute structures or in landscape photography to include the details of tree branches. Slow films need a lot of light, however. It must either be very intense (sunlight or flash) or the camera must be supported on a good tripod so a slow shutter speed below the hand-held limit can be set.

Fine-grained or medium speed films today have speeds of ISO 100/21°, ISO 125/22° or ISO 200/24°

and are available as black and white films (Kodak T-Max), colour films (Kodacolor Gold 100 or Ektar 125) and slide films (Ektachrome 100, Kodachrome 200). The 100 series films are true all-rounders as they are suitable for all subject areas from landscape to sports, macro to portraits. The 200 films are somewhat grainier but can still be used for most subjects. Only in macro photography is a 100 preferable to a 200 series film. For zoom lenses with maximum apertures between f/4 and f/5.6 the 200 films are to be recommended when the sky is overcast as the shutter speeds can still be kept fast. Another reason to prefer a 200 film to a 100 series is that the aperture at equal shutter speed can be closed one stop further which always minimises the problem of vignetting or shading around the edges associated with zoom lenses.

High-speed films have values of ISO 400/27° and are also available as black and white films (Kodak T-Max 400, Ilford HP5), colour film (Kodak Ektachrome Gold 400) and colour slide film (Kodak Ektachrome 400). These films are designed to be used in low light where their high speed can be utilized to shoot hand-held frames with a fast shutter speed (at the expense of the focusing zone which because of the wide aperture will be very narrow). In terms of sharpness, graininess and contrast the modern 400 series films are far superior to their fast predecessors. The grain is still more noticeable, however, than with films of slower speed. In black and white photography this is only a problem where large even-toned areas are involved. 400 colour films cannot be considered all-round films but they come into their own when the light is very low.

Ultraspeed films with nominal speeds of ISO 1000/31° to ISO 3200/36° which by special processing can be pushed even higher, are again available as black and white and colour negative films and as colour tranparencies. As films like Kodak T-Max P3200,

Kodak Ektar 1000, Kodak Ektapress Gold 1600 and Kodak Ektachrome P800/1600 are real specialist films for very low lighting conditions they are hardly ever used in everyday shooting. But you could come to appreciate them when you are trying to take pictures at the circus or theatre without a flash. Careful though; in really dark conditions the use of a tripod is recommended despite the high speed. It need not be a large cumbersome one - the unscrewed leg of a Cullman Magic II serves admirably as a monopod.

Autofocus - Quick and Safe

The Canon EOS 10 is a second generation autofocus camera which focuses quickly and accurately and can cope with almost any subject. However, the photographer should still inform himself about all its possibilities in order to make best use of them.

The camera needs to know the owner's priorities so it can focus automatically. For that reason SLR AF cameras of the first generation were equipped with a small focusing aid in the centre of the viewfinder. The photographer would aim this aid at the subject and the camera focused on it. This was dependent on two conditions. The subject area aimed at must have contrast, e.g. a division between light and dark. The dividing line could not run horizontally or nearly so as the horizontally arranged measuring sensors could not recognize it. The other requirement was sufficient brightness for the contrast to be recognized. When the main subject was not in the centre of the viewfinder, the procedure was to first aim for it, store the focus setting, realign the camera and only then could the picture be shot. Not a problem when shooting a solitary tree inside a corn field but more difficult with a child playing football. If the subject was composed of horizontal structures the automatic mechanism could not focus properly.

These kinds of subjects are easier for the EOS 10 as it is equipped with three focus sensors. The central sensor is coupled to vertically and horizontally arranged measuring cells. The sensors are marked by

three small rectangles easily seen in the viewfinder. Normally the distance is metered by all three sensors. Comparing the values with a basic setting the camera then determines which of the three distances should be selected. Shorter distances usually have preference as in most cases the foreground is more important than the background. The same applies to subjects moving horizontally within the frame, appearing in one focus field, then in another. The lens is set for the main subject which is assumed to be nearer the camera. This works very well when the main subject is picked up by two focus sensors while the third finds the range for the background. Especially when shooting a sporting event or children at play this eases the photographer's work load a great deal. The EOS 10 informs you of the focus sensor selected by lighting up the responding focus mark or marks (which can be switched off by selecting Custom Function 10).

The automatic focus sensor selection might lead to a wrong setting, however, for instance when the foreground is intended as a framework for the main subject positioned further away from the camera. In that case you simply select one of the three focus sensors by pressing the large focus mark button and then turning the setting wheel. The focus sensor just selected will light up - even when Custom Function 10 has been set. By selecting a specific sensor you can focus on the part of the subject important to you. The sensor selected not only determines focusing itself but also the metering of multiple exposures. It focuses on the particular subject part picked up by the AF sensor field and its surroundings. You can therefore avoid the preselection of the left or right focus sensor by switching to spot metering. Spot metering always occurs in the centre of the picture. By combining spot metering with selection of central focus sensor, exposure and focus can be directed accurately on the

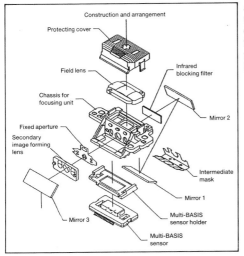

Construction and arrangement

Protecting cover

Field lens

Infrared
blocking filter

Chassis for
focusing unit

Mirror 2

Fixed aperture

Secondary
image forming
lens

Intermediate
mask

Mirror 1

Mirror 3

Multi-BASIS
sensor holder

Multi-BASIS
sensor

An exploded view
showing the
complicated
technology of the AF
unit in the Canon
EOS 10.

important subject part.

The cruciform arrangement of the central sensor enables you to focus on horizontal structures as well. This works with all lenses with a minimum f/number of 5.6 - effectively all Canon EF lenses. Should fast super telephoto lenses be included in the range at a later date they could, of course, also be focused automatically by the central sensor, albeit on vertical or nearly vertical structures only. In order for the cruciform sensor to be used with all lenses up to f/5.6 the basis for metering had to be very small. With wide open aperture the extremely fast lenses - EF 50mm,f/1.0L or EF 200mm,f/1.8L - could on occasion not attain a focus accuracy of 100%. Should you be in the position to afford these giants you might be better off using the EOS-1. But the cruciform metering sensor of that camera would not be able to accommodate the smaller lenses.

Apart from selecting the focus sensor you also have the choice between the EOS 10's two AF-modes - ONE

A simplified illustration of automatic distance metering.

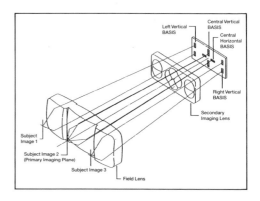

SHOT or AI-SERVO.

The difference between the two is that in ONE SHOT mode half-releasing the shutter will set and store the sharpness for the time the shutter remains half-released. When automatic focusing is impossible, the shutter cannot be released. In AI-SERVO the camera keeps on adjusting the sharpness for the time the shutter is half-released while shooting is possible at any time. From the moment of shutter release until the moment the mirror pops up three more focus measures will be taken. If the camera detects the subject moving it calculates how much the subject is going to move in the time between the mirror popping up and the begin of shutter release procedure and adjusts the last range setting by that amount.

The choice of focus fields and AF-modes is not available when selecting one of the icon programs. According to the subject area selected by the command dial or bar code reader the camera will decide for you. Another variation is added by the icon program green zone. The EOS 10 activates all three focus sensors for automatic evaluation and then switches to the AI-FOCUS mode. This is basically an automatic selection between ONE SHOT for stationary subjects and AI-SERVO for all moving subjects.

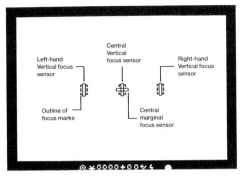

The three focus fields of the Canon EOS 10 - the side fields are arranged vertically, the central field is cruciform. Only the three rectangular focus marks are actually seen in the viewfinder.

Even an AF camera of the second generation still relies on contrast and a certain amount of basic brightness. In the case of the EOS 10 the basic brightness is set at EV 0 - equivalent to an ISO 100 film and 8 sec at f/2.8. If the brightness is below that value the EOS 10 automatically switches on its auxiliary light projecting a red pattern of horizontal bars on to the subject. The projected bar pattern is arranged in such a way that it can be picked up by all three focus sensors. The central beam has a reach of about 10m, the two outer beams 5m each. Even in the dark, differentiation between the main subject nearer the camera and the background further away is therefore possible. The subject will be illuminated and evaluated if found at the edge of the frame and closer than 5m. If the subject is in the centre and the background more than 5m away the EOS 10 will only focus with the central sensor as it cannot find any contrast in the outer fields.

There might be situations too difficult for even this type of sophisticated automation. For instance, if there is enough light but no contrast, or if it is too bright and the system is dazzled, or if the focusing sensors even after manual selection cannot pick up the main subject through the foreground. The easiest solution for these problems is the use of ultrasonic lenses, using Custom Function 7 if necessary. You simply adjust the focus

The AF auxiliary light is focused on the three AF fields.

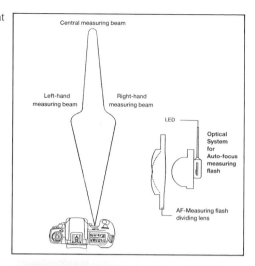

The AF auxiliary light is activated when lighting conditions are too dark.

manually. Other lenses might only require being switched from "AF" to "M" to be focused manually.

Selecting manual focus without creating any of the problems mentioned above is easily done as the switchover only uncouples the AF motor. Focus evaluation and viewfinder display will function as before.

Exposure Metering - In Zones

From integral evaluative metering to centre-weighted integral metering straight on to the complicated multiple-zone evaluation of the EOS 10. Whatever next?

The Canon EOS 10's evaluative metering takes place in a total of 8 zones. Three central fields and five around the edge of the screen.

The three central zones are linked to the three autofocusing points. If focusing is governed by the left-hand sensor, for example, evaluative metering will also tend to the left. This means that the main subject is always exposed correctly.

This can all be done with the three central zones. What is the purpose of the other five?

Basically the exposure meter of every camera is set to an average value. This value represents a standard subject, reflecting as much light as a grey area with a reflection factor of 18%. A surprising number of subjects correspond to the standard and are correctly evaluated even by simple exposure meters. Very light or very dark subject parts within the frame could distort the evaluation result quite significantly - a bright blue sky above a Mediterranean landscape or a very dark background of a portrait, for example. By comparing the results of several evaluation areas the camera automatically recognizes such a situation and adjusts the exposure accordingly.

Multiple-zone evaluation obviously contributes a great deal to technically successful photography. (Whether the photographs are "nice" or "good" is

another story as that has nothing to do with the camera!)

If the subject deviates a great deal from the standard you might prefer to determine the evaluation yourself. The Canon EOS 10 offers several possibilities.

Firstly, in order to match the exposure exactly to a particular subject part you can select partial metering where the reading is stored. Partial metering can also be used to evaluate a an object corresponding to the 18% reflection factor in order to create a neutral exposure. Such a substitute evaluation is recommended when the subject on the whole is very light or very dark .

Secondly, you could make use of exposure compensation. You might not utilize the aperture stops of +/– 5 but altering the aperture setting by 1/3 to 1 stop could just save a picture. Exposure compensation is appropriate whenever fine adjustments are required to intensify or lighten the colours, for example. The exposure compensation is controlled by the time in the case of auto-timing or by the aperture in the case of automatic aperture setting and the selected values are retained. In AF mode the compensation is also controlled by the shutter speed to keep the aperture required for the desired focusing zone. Time and aperture control the compensation in the program mode. The compensation factors cannot be programmed in manual operation - obviously.

Thirdly, automatic exposure bracketing (AEB) can be used which automatically makes three exposures of the same scene. Normally one exposure is under, the second at, and the third above, the standard metered value. It is possible to adjust the amount of under or over exposure by entering a compensation factor in addition to the AEB value. AEB is then based on the adjusted exposure value and again the exposure sequence on the film is from darkest to lightest. In the

Distribution of
metering field
sensors

Evaluative metering
reacts to different
degrees of lightness
and darkness.

Multi-field
measuring sensors

AEB mode, too, the compensations are made via the aperture in Tv mode, and via the time when Av mode is selected. For manual operation the EOS 10 regards the value set by the input dial (without the partial metering button) as the more important.

Each adjustment to the exposure values has a bearing on the entire picture. If before compensation, one part of the frame was too dark and was adjusted to the correct value, other subject parts that were correct before adjustment will appear too light on the final picture.

A clever way of solving this problem is the provision of more light to the too dark main subject. The picture contrasts are mellowed and the exposure is balanced. The EOS 10's built-in flash serves this purpose - among others - admirably. It can be switched on when the main subject is too dark, but the background or surrounding too light. In Tv mode the A-TTL (Advanced Through The Lens) flash metering provides correct exposure for the background by selecting a time appropriate for the aperture, and for the main subject a flash intensity

appropriate to the aperture. The position of the main subject is irrelevant in this context as the flash exposure is coupled to the AF sensors as well.

If the light emitted from the small flash appears too harsh, as it easily might be the case in against-the-light exposures at dusk, lightening the picture should be made with a reflecting foil as available from the Hama company. The only problem is that you have to carry the foil around with you and someone has to hold it. The flash is always there being built into the camera.

Backlit subjects present a challenge to any kind of exposure meter.

Exposure Control - How Long, How Much?

Even in the most up-to-date cameras exposure is governed by two factors which also controlled the operation of the old plate cameras - shutter speed and aperture. What do they do?

The Canon EOS 10 has a focal-plane shutter. You can see it when you open the camera back. It consists of two blinds composed of separate metal leaves. One blind covers the image plane light-tightly. After shutter release the blind opens to enable the light coming through the lens to reach the film. At the end of the exposure time the second blind covers the film again. If the exposure time is very short, the second blind begins closing before the first has finished opening and a more or less narrow slit travels in front of the film at great speed. Shutter speeds are available between 30 and 1/4000 sec. Manually they can be adjusted in half-step increments and automatically with infinitely variable settings. Each whole step doubles or halves the amount of light reaching the film.

Every Canon EF lens has a built-in iris diaphragm closing towards the centre. That means in effect that there will always remain an opening in the middle, the aperture. Normally the aperture is completely open in order that the subject can be seen as clearly as possible in the viewfinder, and normally it only closes up a fraction of a second before exposure to the value set manually or by one of the automatic functions. Manually the aperture can be controlled in half-stops, the automatic mode can use infinitely variable settings.

The size of the aperture which is increased or reduced by the lenses in front of it, determines the amount of light reaching the film during the time the shutter is running. Each whole stop alteration doubles or halves the amount of light in relation to the previously-set aperture. If you reprogram the partial metering button to become the depth of field preview button (Custom Function 11), a glance from the front through the lens will show you the action while a look through the viewfinder shows the effect.

Aperture and shutter operate in the same way; the alteration by one whole stop doubles or halves the amount of light reaching the film. When you close the aperture and reduce the shutter speed by one value respectively the aperture will let through half the amount of light as before and the shutter twice as much. Altogether the amount of light remains the same. All the shutter and aperture combinations resulting in the same exposure have an "exposure value", which in turn corresponds to a certain subject luminance and film speed. The EOS 10 recognizes the film speed either by reading the DX-code or by your manual setting. Exposure metering establishes the subject luminance and the combination of both values results in the exposure value the film needs to be exposed to in order to record the picture correctly.

Exposure values, sometimes incorrectly called "light values", are numbers assigned to combinations of f/numbers and exposure times that represent indentical exposures of the film in the camera.

Such combinations are shown here:-

f/number	1.4	2	2.8	4	5.6	8	11	16	22	32
shutter speed (sec)	1	2	4	8	16	32	64	128	256	512

All the foregoing combinations have an exposure value (EV) of 1.

Towards the upper end of the EV scale, namely

EV15, the combinations of f/number and shutter speed apply as follows:-

f/number	1.4	2	2.8	4	5.6
shutter speed(sec)		$^1/_{8000}$	$^1/_{4000}$	$^1/_{2000}$	$^1/_{1000}$

f/number	8	11	16	22	32
shutter speed(sec)	$^1/_{500}$	$^1/_{250}$	$^1/_{125}$	$^1/_{60}$	$^1/_{30}$

In Av mode a preselected aperture is fixed and the EOS 10 sets the only matching shutter speed.

In Tv mode you have fixed the shutter speed and only one aperture will match the calculated light value which is set by the EOS 10.

In multiple zone evaluative metering the EOS 10 first determines which aperture and what range with given focal length will provide the required depth of field. Then according to the aperture the only possible shutter speed for the light value given by the exposure meter is set.

In the program selection mode the EOS 10 cannot select shutter speeds or apertures indiscriminately - although every speed/aperture combination would result in correct exposure. But here again there are preselections according to the program chosen: as fast a shutter speed as possible to prevent camera shake or to freeze movements, a small aperture to achieve a large depth of field or an aperture one value smaller than the f/number to separate a portrait from its background on one hand, but to have a sharp image from the tip of the nose to the ears on the other.

A subject like this presents no problems for the automatic program as neither a certain shutter speed nor a specific aperture is required.

Foolproof - No More Swearing!

Committed photographers often express doubts regarding cameras with automatic programming. Programs kill any creativity, they argue. This is only true, if you call fiddling with the camera "creativity",

Just noticed out walking and left entirely to the EOS 10

although the camera can get results quicker and better.

The Canon A-1 was the first SLR camera to feature automatic programming as well as automatic aperture and shutter controls - and it was a very sophisticated

camera at that. One would sneer at it but secretly turn the command input dial to **P** anyway. If it does not matter what aperture is selected for a certain depth of field or which shutter speed is set to avoid blurring or freezing of movement, one shutter speed/aperture combination is as good as another - and such a combination automatic programming can select quickly and reliably. The camera won't run out of a suitable aperture because the shutter speed is too fast. The photographer can easily make that mistake and before it has been discovered the opportunity of a good shot has passed.

Modern automatic programming is safer still. For example the program changes according to the focal length and takes into account that a telephoto lens requires fast shutter speeds - to avoid camera-shake blur - and that for a wide-angle lens a small aperture would be preferable to make use of a wide depth of field. And the addition of a shift feature enables the photographer to alter the shutter speed/aperture combination within the light value at any time to make use of a certain depth of field or to create a blurred effect after all.

A camera fitted with automatic programming is, indeed, foolproof as anyone able to press the shutter can achieve correctly exposed pictures. This does not mean creativity is diminished. The composition of colours and shapes, light and shade, a certain angle and various focal lengths are not determined by the user being able to select a certain shutter speed or aperture. Of course, these functions do very often have an effect on the final shot. But in the end it is the eye of the photographer that determines the picture. And it is easier to include an element of creativity when you are not busy looking after aperture and shutter speed.

Converging verticals as a result of an acute shooting angle. Not a disadvantage as it emphasises the height of the slim column.

Green Zone - A Program for Every Situation

High-tech equipment like the EOS 10 is not necessarily difficult to operate. Successful pictures can be created with the help of its Green Zone.

The first setting after the L position is the Green Zone rectangle. In this mode the camera becomes fully automatic. Not all custom functions operate when this program is selected. But functions like manual film rewind to prevent the leader disappearing into the cartridge and overriding the DX-code with manual selection of film speed remain operative.

The system of automatic programming is based on focal length. Fast shutter speeds are usually selected for long focal lengths to prevent camera-shake blur and small apertures are selected for lenses with short focal lengths to provide as wide a depth of field as possible.

This is not an arbitrary selection but quite logical. The longer focal lengths are generally chosen to enlarge distant subjects. The narrow angle often pushes foreground and background out of the frame and a wide depth of field is therefore not required. On the contrary, a tele shot often turns out better if the

A zoom lens helps a great deal to condense such a subject which is dominated by the colours red and blue.

main subject is separated from a blurred, out of focus background by the narrow depth of field.

When lenses with short focal lens are used, the system works in the opposite way. Taken from the same position and using the same aperture these lenses provide wider depths of field which can be increased by stopping down the lens. When taking landscape shots or pictures in small rooms this would be an advantage as you want these frames to be sharp from the front right through to the back. For that reason the camera automatically selects as small an aperture as possible. This, of course, means the shutter speed is slow, but under the rule of thumb "Slowest shutter speed for hand-held pictures = one divided by the focal length in mm" the danger of camera shake blur only becomes imminent when lenses with short focal lengths are used at 1/45 sec or even longer.

In the green zone the EOS 10 automatically switches to the AI-Focus mode, which in effect means that the ONE SHOT mode is used for stationary subjects and the AI-SERVO mode for moving subjects. The EOS 10, however, does not tell you whether ONE SHOT or AI-SERVO has been selected. You only find out when you cannot release the shutter because no focusing occurs.

The built-in flash is automatically activated when the camera requires additional lighting - not only in the dark but also when backlit situations are recognized. This obviously does not apply when an additional flash unit is fitted in the accessory shoe.

The Green Zone is useful for a wide range of subjects.

Subject Settings - Quick and Easy

Certain subjects require the photographer to keep to a number of rules to achieve optimum results. The rules are normally established by taking a lot of pictures and learning from mistakes. The EOS 10 saves you the trouble as all the experience is stored in its memory.

Next to the Green Zone symbol there are four icons displayed on the command dial which are connected by a silver-coloured background. These icons represent four subject areas - portraits, landscapes, close-ups and sports/action.

Selecting one of these programs turns the EOS 10 into a camera specifically geared to that particular subject as the AF target fields and AF-mode, the type of exposure metering, the frequency of film transport and the automatic use or non-use of built-in flash are all preset.

The portrait program should be used in conjunction with a lens offering a focal length of between 70mm and 100mm. A satisfactory perspective can be achieved when a distance is chosen that allows head and shoulders down to the upper torso to fill the frame. Suitable films would be Ektachrome 100 for colour slides or Ektar 125 for colour prints. Films of higher speeds are too grainy while slower films would emphasize the smallest wrinkles and skin blemishes too much. The EOS 10 automatically selects evaluative metering for portraiture so the exposure is determined by the main subject - the person in front of the camera. The aperture is set at a value one stop below the

maximum. This ensures that the person's depth of field is caught but the background remains out of focus. The difference between blurred and sharp is defined even more precisely when one of the ultrasonic lenses of the second generation is used (EF 35-135mm,f/4-5.6, EF 70-210mm,f/3.5-4.5 and EF 100-300mm,f/4.5-5.6) These tell the camera the exact focal points. It calculates the scale of the picture from distance setting and focal length and selects the required aperture for the depth of field. Through continuous film wind it is possible to react very quickly to changes in expression or position and the best shot of the series can be chosen afterwards. The ONE SHOT AF prevents out of focus pictures, the automatic addition of the built-in flash provides the correct exposure in poor light or backlit situations.

When the landscape program is chosen the EOS 10 selects the ONE SHOT setting as these subjects are usually stationary. All three AF target fields are used to focus on specific areas. The single shot setting of the motor prevents inadvertent multiple exposure of one and the same subject while evaluative metering ensures that the effect of a very light sky or a dark foreground is not too great. This setting automatically selects a small aperture to include as much landscape in the depth of field as possible. If necessary the aperture can be opened up in favour of a faster shutter speed to reduce the danger of camera shake when using long focal lengths. The built-in flash is inoperative in this program as the illumination of the entire landscape is perhaps a trifle beyond its range.

Wide-angle lenses are probably the best choice to capture the extent of a landscape. But telephotos are just as suitable for this subject area. They reduce the perspective - far distant points seem closer together and the atmosphere of a landscape can be intensified. Films of any speed can be used; from the extremely

sharp Ektachrome 50 HC which brings out even the smallest flower in a meadow to the sophisticated Ektachrome P800/1600 which by its graininess can give an attractive effect when shooting at dusk.

The close-up setting combines partial metering with preselection of the central AF target field. This is based on the evaluation of a great amount of macro photography where the main subject is usually found in the centre of the frame. (If you prefer the main subject to be off-centre you can choose from all the other automatic functions instead). The setting in this program is again ONE SHOT as the close-up is usually required to be in focus. If necessary the built-in flash is added, the single shot setting prevents inadvertent multiple exposures. Small apertures are preferred, if necessary with the aid of the built-in flash which increases the depth of field.

Although EF zoom lenses are very suitable for macro photography two lenses can be specially recommended in this context; the EF 50mm,f/2.5 Macro and the EF 100mm,f/2.8 Macro fitted with an ultrasonic focusing motor. These lenses are specially designed for close-ups as they achieve a very high performance even with very small distances while the zooms are more suitable for somewhat greater distances. When using a macro lens films like Kodachrome 25 or Ektar 25 should be selected to depict very fine details at their best. Obviously an adjustable tripod is a great help as the longer the exposure the greater the danger of camera-shake blur.

In close-up photography the use of one of the ultrasonic lenses of the second generation comes into its own as it tells the camera the focalpoints. The distribution of blurred and sharp areas is based on the scale calculated from the distance and exposure settings which is of special interest when using the EF 100mm,f/2.8 lens.

The sports program simplifies the photography of moving subjects. All three AF target fields are activated, but the illumination of the target fields is switched off however. You must only make sure that the subject is included in the central focus mark for the first shot after which it can move freely within the frame. By free selection of the target field in conjunction with the AI-SERVO mode the focus tracks the subject right up to shutter release. Even movement between mirror up and shutter operation is included in the calculations and the chance to achieve a sharp image of a steadily moving subject is greatly increased. The film transport is automatically set to continuous wind which enables a shot to be repeated quickly if necessary. In addition a whole series of action shots is possible through the high transport frequency of 5 frames per second. Correct exposure in most cases is achieved by evaluative metering which emphasizes the main subject. In a few difficult cases, however, for example when shooting small objects in front of a light background, it might be more appropriate to select automatic aperture and exposure compensation settings. This program prefers fast shutter speeds to freeze movements. Also focal lengths from 135mm upwards are preferable for this kind of photography, i.e. telephotos and tele zooms are very suitable. To prevent camera-shake again fast shutter speeds are used.

Films which allow the necessarily faster shutter speeds are mainly found in the fast and very fast ranges. Although Kodachrome 200 can give good results in bright daylight, Ektachrome 400 or perhaps even Ektar 1000 permit the more suitable faster shutter speeds. The green zone and the four subject areas are a great help especially to the inexperienced EOS 10 user without creating too many problems and particularly without wasting a lot of film on bad shots. The subject areas are quite basic, however, and geared to average

The landscape program provides as wide a depth of field as is possible under the given circumstances.

situations. For more specialized areas like portraits with background, children during a firework display or landscapes at dusk the EOS 10 has a special feature of the bar code programs.

The Bar Code Program – Correct Settings for Difficult Situations

Bar codes and their special readers have been around for a while. They are used in department stores and supermarkets to mark the goods. Now these patterns of black and white lines have entered photography as well.

When you see the EOS 10 for the first time you will notice a small round crater-like button on the bottom front right of the camera. This is the bar code receptor or docking station for the bar code reader and presents quite a novelty in the world of cameras.

Together with the bar code booklet, the receptor and reader form a trio which helps the novice as well as the experienced photographer quite considerably in avoiding trouble and wasted film. Starting point is the bar code booklet listing at present twenty-three different subjects which are divided into five groups. The groups are marked by different colours and cover the areas "Portraits", "Childhood", "Weddings", "Close-ups" and "Various".

Each subject is represented by a characteristic picture and accompanied by a bar code, a short text and a series of symbols for suitable camera settings. These symbols show the suggested focal length, the focal length used, whether a tripod is required, which film speed should be used and whether a flash is necessary. The short texts are also informative giving hints on positioning the subject etc.

From the twenty-three subjects in the booklet select the one closest to your actual subject, set the command

The bar code reader and subject booklet enable even the beginner to achive good results with diffcult subjects.

dial to the bar code icon and switch on the reader (a red light will be visible at the tip) and starting at the small square draw it steadily over the code from left to right. When the code has been read correctly it is confirmed by a short audible signal. This can be quite a lengthy procedure as the reader has to be held absolutely straight for the code to be received. Make sure the bar code booklet lies flat on a level surface. On the road you could use the back of the camera body as a suitable alternative. Within eight seconds push the domed rear end of the reader against the bar code receptor on the camera and press the memory button on the reader. Again an audible signal can be heard and the EOS 10 is now programmed for that particular subject. The bar code symbol is displayed on the LCD panel. The code remains stored in the camera even when it is switched off. To check the last bar code program selected, simply turn the command dial to the bar code symbol and press the button of the bar code receptor. The program number last recorded will appear in the LCD panel. The information stored in the bar codes contains AF target fields, AF mode, metering, film wind frequency, exposure control with

The rounded end of the bar code reader is set into the hollow of the receptor.

fixed shutter speed or aperture, if necessary. In some cases both shutter speed and aperture are fixed and any subject luminance different from the example subject will lead to a wrong exposure. It is possible – and perhaps even planned – to increase the number of subjects. How far that will go is anyone's guess. But it is quite conceivable that the EOS 10 could be programmed for special effects with the bar code system.

There are no doubt a lot of people who spurn the bar code program as there is no creative rapport with the subject. But on the other hand it is a very useful feature enabling the beginner to work in areas where he would normally fail without help. It also eases the work load of the experienced photographer – for example when he is expected to photograph a friend's wedding and no mistakes are allowed.

P - The Variable Program

The AE program mode is most suitable for situations where you need to be quick and where actual shutter speed and aperture settings are not vital.

If you simply want to shoot without bothering about technicalities the EOS 10 offers two possibilities. You can either select the green zone or the **P** program. In the green zone the camera not only determines the exposure but also the choice of AF functions, film wind and the use of the built-in flash. Also the shutter speed/aperture combination set by the camera cannot be altered.

When **P** is chosen, however, you determine the AF functions, one shot or multiple exposures, exposure compensation and so on - All the functions of the EOS 10 are available including the Custom Functions.

Program mode in fact only means that the camera sets shutter speed and aperture automatically according to the light conditions and lens used, i.e. telephotos have fast shutter speeds, wide-angle lenses have small apertures.

Contrary to the green zone the shutter speed/aperture combination is not fixed in the **P** mode. Within the given light value any other combination can be set by simply turning the input dial. The alterations appear in the information line at the bottom of the viewfinder.

This program shift facility makes the **P** setting the most useful variant of exposure control. If the subject does not require any particular shutter speed/aperture

To get the entire house front into the frame the speed/aperture combination of the automatic program was shifted to a smaller aperture.

setting simply dial **P**. And just in case - place your index finger on the input dial and operate the shutter with the middle finger. As soon as you think a different shutter speed or aperture would be better you turn the input dial, set the right combination and press the shutter.

Of course, you can select the values you prefer in other automatic modes. The EOS 10 will tell you when you selected the wrong settings. In the **P** mode, however, the correct values are set automatically which can occasionally save a picture.

Tv - You Decide the Speed

Automatic shutter speed priority is quite a tradition with Canon. Even the first automatic SLR camera, the Canon EF, featured this function and naturally the EOS 10 is no exception.

Shutter speed priority on the EOS 10 is selected by turning the command dial to **Tv** (Time value). You chose a shutter speed while the camera automatically sets the aperture to provide an exposure according to film speed and subject luminance.

The range of shutter speeds is quite extensive on the EOS 10. On switching to Tv mode the camera offers a shutter speed of 1/125 sec to start with. This is useful as the most frequently-used speeds range from 1/15 to 1/1000 sec and can easily be reached by turning the input dial three stops either way.

Of course, the EOS 10 has a wider range than that, from 30 to 1/4000 sec to be precise, at 1/2 stop increments. There are cameras with speeds of 1/8000 sec but the range of the EOS 10 is quite enough for most applications.

What are the fast speeds for?

To begin with they are a convenient way to eliminate camera-shake problems. The faster the shutter the less likelihood of your trembling finger being transferred to the camera. As more pictures are ruined by camera-shake than one would think, the rule of thumb "One divided by focal length" to determine the hand-held limit should be taken seriously and the shutter set one stop faster. The long 100-300mm,f/5.6 lens should be

When switched to Tv, the EOS 10 offers the 1/125 sec setting.

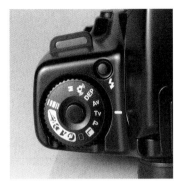

used in the hand at 1/500 sec rather than at 1/350.

The second application for fast and super-fast shutter speeds is photography of moving subjects. The fast speeds freeze the movement. These types of shots can be divided into two groups. On the one hand there are the shots which would lose their effect with a slow shutter speed. They show up what is invisible to the eye - high-jumpers seemingly floating over the cross-bar, motorcyclists speeding around a bend almost lying flat on their side or skiers in a cloud of snow crystals. On the other hand there are the shots that because of the frozen movement can hardly be distinguished from the same subject taken when still. A sharp image of a racing car in front of the stand which doesn't even show blurred tyres is an example.

Advertisements for cameras rarely emphasise the slower speeds although these are more important for interesting pictures than the very fast speeds. It need not be the full 30 sec that can be preselected by the EOS 10 or controlled by shutter priority and which offer a comfortable back-up.

What can the slow speeds be used for?

For once, they let enough light reach the film when conditions are dark, the aperture can only be opened to 5.6 and a film like Kodak Ektachrome HC, sharp but

not very fast, is loaded.

Slow shutter speeds allow some fascinating shots to be taken at dusk or early evening. The colours of the evening sky ranging from the familiar red through orange to a soft turquoise can all be captured on film and again it is possible to use sharp, but slow films to feature even the twigs of a line of trees.

The slower shutter speeds can also be used, not to avoid movement in the picture, but to include it. We are not talking of camera-shake here, the camera and lens must be stabilized for all exposures with shutter speeds below the hand-held limit. A solid tripod is very useful here, although not always convenient. The back of a seat, a fence, a low wall or even a lamp post all make suitable alternatives but give sufficient support for your EOS 10 and the telephoto.

To convert movement photographically there are two possibilities. The first is to support the camera properly, select a slower shutter speed and press the shutter. The result is a picture featuring a sharp background and a moving subject. By grading the shutter speeds you could, for example, freeze the water of a stream running over a few pebbles, which requires a fast shutter speed. If you prefer to let the water flow like a mist over the pebbles you need a rather slower shutter speed.

The second possibility is to attach the EOS 10 to a tripod with a pan and tilt head and set it to the correct height. Make sure that it is freely movable horizontally, though. Again a longer shutter speed is chosen. As soon as the subject appears at a certain point you press the shutter and move the camera in the direction the subject is moving. After a few attempts you will achieve a picture where the main subject is almost totally sharp, but the background is speed-blurred. In both case the movement becomes part of the subject - and the picture becomes an eye-catcher.

Whether running water can be seen as moving in the picture is determined by the shutter speed selection.

Av - All about the Aperture

The aperture priority mode is seen by many photographers as the more creative program as the aperture determines the picture to a greater degree than the shutter speed.

To select aperture priority on the EOS 10 turn the command dial to the **Av** position. This stands for aperture value meaning you select the aperture and the camera sets the correct shutter speed appropriate to the lighting conditions and film speed.

When switched to **Av** the camera's initial setting is f/5.6. This is a useful value as all EF lenses feature an aperture of 5.6. Even for the slow tele zooms this value can be selected. All the aperture values featured by a lens are now available via the input dial - in 1/2 stop increments. Simply turn the input dial and watch the values change in the viewfinder and LCD panel. Turning the input dial to the left a lens with f/2.8 will show aperture values from 5.6 to 4.5 - 4 - 3.5 - 2.8. You preselect in fact a large aperture for the frame, in this case the largest the lens can offer is f/2.8. Preselection in this context means that moving the lens ring has no effect on the aperture as it will remain open until shutter release and you can easily evaluate the viewfinder picture with maximum light.

Turning the input dial which replaces the lens ring in Av mode to the right you reach steps 6.7 - 8 - 9.5 - 11 - 13 - 16 - 19 - 22. Some lenses can be stopped down even further to values of 27 and 32. By turning the input dial to the right you set a small aperture.

The reason that values up to 2.8 apply to large apertures and values to 22 and 32 to small apertures stems from the fact that the size of the aperture is given as the ratio of its diameter to the focal length. Therefore an aperture whose diameter divides into the focal length only 2.8 times is bigger than a diameter that divides 22 times.

Opening or closing the aperture obviously lets more or less light reach the film. When the aperture is only used to regulate exposure it might be better to select **P** mode which controls the aperture as well and is quicker than by hand.

The purpose of aperture preselection in **Av** mode is the composition of the picture.

The aperture has a direct effect on the extent of the depth of field which ranges from in front of to behind the distance the lens has been focused to.

The smaller the aperture the larger the depth of field. This applies to every lens, whether wide-angle or telephoto. However, when both have the same aperture set, standing in the same position the wide-angle lens right from the start features a greater depth of field than a lens with a narrower angle.

Depth of field becomes narrower the wider the aperture is opened. With very fast lenses like the Canon EF 50mm,f/1.0L it can even shrink to a few centimetres.

Related to the subject, that means that the image can be sharp from front to back or on another occasion be only sharp in parts while the rest appears more or less

One subject can be suitable for many pictures - as shown by two frames of one series on the opposite side. A zoom especially is useful to capture different areas. Even rather unassuming subjects like an old gate can be presented in many different ways.

The four pictures on the following double spread were taken using the motor and tracking focus and a zoom lens kept the car in view.

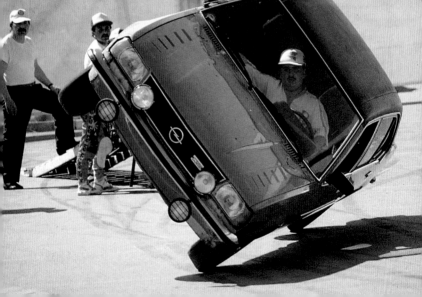

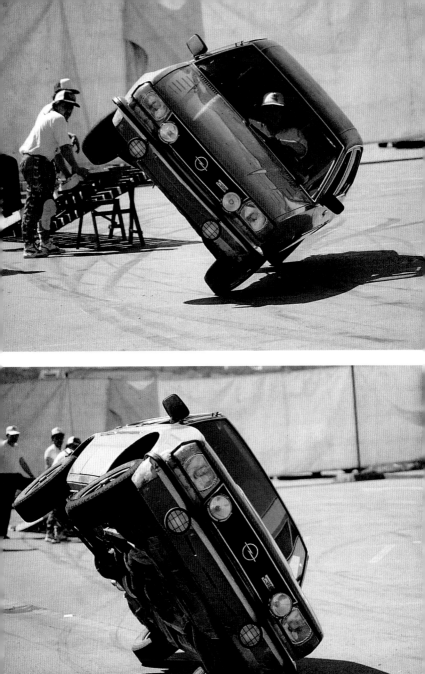

28 mm

35 mm

50 mm

85 mm

100 mm

135 mm

200 mm

300 mm

blurred.

When should a small aperture be selected for extended sharpness? Simply whenever as much of the picture as possible has to be sharp but the area of depth of field is not required to be fixed exactly as the EOS 10 offers the correct determination through its **DEP** AE program.

A small aperture is therefore the correct choice when out searching for a beautiful landscape with a wide-angle lens. There is little danger of having too slow a shutter speed for the small aperture in bright sunlight.

A small aperture can also be preselected to ensure the greatest possible depth of field when using a telephoto lens. It is important, however, that the light is bright enough to permit the fast shutter speeds to avoid camera-shake. If necessary use a fast or very fast film or make sure the camera is well supported.

A large aperture is selected when you want to emphasise and stress part of the picture though selective focusing; sportsmen in the stadium, a poppy in the corn field, a colourfully-dressed child before a grey wall. This technique is the more important in portraiture where a quiet background is required. And it is just as irritating when the focus is on the nose or ears of the subject and the eyes are out of focus. Always make sure that the selective sharpness includes the eyes in portrait photography.

The open aperture is, of course, no cure for a busy background. When main subject and background lie

Focal lengths of 28mm to 300mm used from the same shooting position, which proves that any focal length can be used for landscape photography and that the normal focal length of 50mm need not be boring.

When the aperture is opened wide the main subject can be set off well against a blurred background.

close together the separation through the narrow depth of field is less obvious than with a greater distance between the subject areas. To check whether you are happy with the distribution of sharpness the EOS 10 offers the option of Custom Function 11. The partial metering button can now also stop down the aperture. Partial exposure metering now involves closing the aperture at the preselected value. The viewfinder image becomes darker and the extent of the depth of field can be seen clearly. If you are not quite satisfied, simply turn the setting ring. The aperture increases or decreases and the effect can be observed directly in the viewfinder. Combined with Custom Function 12, evaluative metering is set and prior to shooting the aperture can be closed according to the value by

pressing the partial metering button.

There is no danger of inadvertently releasing the shutter if you first press the partial metering button and then place your finger on the shutter release button which does not react in this case. But when the release is partially pressed first and then the partial metering button is activated, you can shoot straight away by releasing the shutter fully.

The partial metering button also functions with other kinds of exposure control, but in connection with aperture priority it is especially useful as it allows the picture to be composed by the distribution of depth of field planes.

DEPTH - Depth of Focus, Depth of Field?

Focus is one of the most important elements in the creation of an image. Should the main subject be isolated from its surroundings? Or should the entire picture be sharp from front to back? The EOS 10 allows all kinds of possibilities - quickly and safely.

Basically the lens only focuses on one subject plane. If you use an EF 50mm,f/1.0 or an EF 300mm,f/2.8 lens try using a short distances. The focus plane can be seen quite well. As soon as you increase the distance or shut down to perhaps f/8 or both together, and you press the partial metering button you will also be able to see how the focus plane becomes a focus field or depth of field. And if you used the wonderful EF 24mm,f/2.8 instead but with the same f/8 and same distance you would notice after pressing the partial metering button again that the depth of field has become greater.

The extent of the depth of field is therefore determined by the distance and the aperture and follows the following rules:

The smaller the aperture the larger the depth of field.

The longer the shooting distance the larger the depth of field.

The shorter the focal length the larger the depth of field.

Each rule only applies, however, when the other two values remain unchanged, i.e. the depth of field of a wide-angle lens is only larger than that of a telephoto

A small aperture results in an extensive depth of field.

when both are set to the same shooting distance. By stopping down the telephoto the difference in the extent of the depth of field can be decreased or even eliminated.

The depth of field provided by the camera can be taken as it is which is fine for casual shooting. The EOS 10's precise autofocus always ensures that the main subject is in focus, and the background is usually unimportant in this case anyway.

The depth of field can also be selected quite deliberately. Landscape photography, for example, requires a wide depth of field to give the impression of expanse, whereas an extensive depth of field is needed in still life photography to ensure all subject areas are in focus. A narrow depth of field can be useful to isolate detail from a busy background - objects or portraits appear more lifelike before a blurred background.

The extent of the depth of field is naturally taken into account in the camera's subject programs but they follow only broad values. The AE **DEP** setting allows the depth of field to be adjusted to the subject of the moment.

To select a specific depth of field there are several options. In all cases turn the command dial to **DEP** and activate one or all three of the focus marks.

If you have chosen all three focus marks make sure that your main subject is covered by all three. The camera will find the shortest and longest distance and sets the aperture, giving in conjunction with the focal length of the lens a suitable depth of field.

You can get even more precise results by using **DEP** plus one AF focus mark. With your selected focus mark, home in on the front and rear limits of your chosen depth of field and lightly press the shutter release. The camera will show "dEP 1" and "dEP 2" one after the other in the viewfinder. The required extent of the depth of field is calculated from these two values.

The EOS 10 then calculates a suitable aperture and, of course, the distance. The necessary aperture for the depth of field determines the exposure control.

The aperture display in the viewfinder will start to flash when the aperture range of the lens is not sufficient to give the required depth of field.

Very large depths of field need very small apertures with shutter speeds that are below the hand-held limit, especially when the light conditions are low. In such cases a tripod is recommended. It need not be a large one - the Cullman Magic 2 is suitable for a lot of situations and can be folded up to fit into the camera bag.

There may be situations where no tripod is available and you find that a shutter speed of 1/30 sec needs to be set for an aperture of f/11. This would cause camera-shake blur with your 70-210mm tele zoom set to a focal length of about 90mm. If you cannot support the camera without altering the frame, simply turn the input dial until 1/90 sec and aperture f/6.7 are displayed. The aperture value will flash to indicate that the required depth of field cannot be reached but you approach a depth of field close enough to avoid camera-shake.

A large depth of field is not always desirable. On the contrary, to define a subject by selective focusing the depth of field should be as small as possible. This can be achieved by using the central focus mark and evaluating the subject twice. The result is a depth of field as small as possible. But you can obtain the same effect quicker by using automatic shutter speed priority with the lens utilizing the longest focal length.

Camera-shake Alert - Keep Calm!

Tele zooms are some of the most popular lenses. But the longer the focal length the greater the danger of the slightest trembling being transferred to the picture. But who can tell whether one's tremble will lead to camera-shake or whether one is still safe? That's where the EOS 10's camera-shake alert program comes in.

Observing the well-known rule of thumb "Slowest shutter speed for hand-held pictures = one divided by the focal length in mm" is quite safe. But it is possible to ruin the picture using fast shutter speeds because after a long day's hiking around the countryside you are somewhat tired. And you might feel that you are able to keep the camera steady when using the longest focal length of your EF 70-210mm even at 1/125 sec. If the result is blurred, the focal length was not at fault, it was your trembling.

In any case the Canon EOS 10 offers a camera-shake program which can be selected by turning the command dial to the shaking camera symbol.

When this program is chosen, the lens is initially focused with the central focus mark. Then the focus field whose cruciform sensors react to both vertical and horizontal structures is reprogrammed as the "shake" focus field. Instead of structures, vertical and horizontal movement is now being recognized. The EOS 10 calculates the degree of camera-shake and alerts the photographer by superimposing various camera symbols on to the viewfinder image. Based on centre-focused eight-zone evaluative metering this

information indicates any deviation from the hand-held limit. This program sets faster shutter speeds resulting in a small depth of field when using long focal length lenses.

A small camera symbol in the viewfinder image will light up when the right combination of focal length and shutter speed is set to prevent camera-shake blur.

If the aperture is fully opened, but the shutter speed still slower than the given rule of thumb "One divided by focal length" the shutter will not be locked but three marks will appear in the viewfinder indicating to the photographer what the situation is.

If the camera symbol lights up and flashes, the shutter speed is up to two steps below the hand-held limit; if it just flashes, the shutter speed is more than two steps below the hand-held limit. In both cases the use of a firm support or a tripod is recommended. Indoors, a table tripod like the Cullmann Mini Magic might be a good choice; outside a clamp tripod like the Cullmann Clamp Magic is useful as it can be fastened to a fence, a branch or a railing.

It is clear therefore that the Canon EOS 10's camera shake program is based both on the measuring of the extent of camera shake and on the compromise between focal length, resulting hand-held limit and shutter speed. As a result the camera symbol blinks occasionally, although the camera is well supported. In that case use Custom Function 14 which when activated warns the camera of any actually measured shake irrespective of the shutter speed. Therefore it is wise to select the combination of camera-shake program with Custom Function 14 if you plan to shoot hand-held or with supported camera. The camera will tell you whether it is worth taking the picture or not.

In order to capture the window as large as possible, a long focal length had to be chosen. The camera signalled that there was no danger of camera-shake.

Manual Control - Slow but Sure

Despite the incredible range of automatic functions the EOS 10 can still be controlled manually. The only question is whether to use this mode or not.

Manual setting of shutter speed and aperture allows your film to be exposed very accurately. "+" appears in the viewfinder to tell you of overexposure, "-" warns of underexposure. Both symbols lighting up together mean correct exposure is possible, but that you would have expected from the automatic **P** program, too. Even if you want to have a different exposure from the one selected by the EOS 10 it is better to remain in the automatic mode and make any alterations by entering the correcting factors.

But manual setting of aperture and shutter speed can be very useful, as when shutter speed and aperture have been set for the prevailing light you can shoot any subject that happens to come along, on the beach for example. Whether the subject is near or far, wearing a white bathrobe or a deep suntan - the background is always the same giving the pictures a great sense of continuation.

Manual exposure is also recommended for panorama photography, which incidently is undertaken best from left to right, ensuring that the shots appear in the right sequence when the film is developed.

Lenses with a focal length ranging from about 35mm to 85mm are to be recommended for panorama photography. With the longer focal lengths more frames are taken so that the change from one frame to

the next is less noticeable. Useful accessories for this type of photography are a spirit level and a tripod with pan and tilt head. Another area were manual exposure is appropriate is in the studio. You can take one exposure reading by hand-held meter in order to shoot all frames with this reading. Especially when taking individual shots of subjects like machinery with varying reflection factors, metering the incident light gives very good results.

A picture from a focal length comparison. To keep the exposure setting constant, exposure was measured first and then the required shutter speed and aperture set manually.

Multiple Exposure - Unlimited Possibilities

Trying to combine several motifs in one frame used to be quite difficult with conventional SLR cameras and the end result was rather disappointing in most cases anyway. It is easier and safer with the Canon EOS 10.

A beautiful moon over a deserted palm beach - was the moon really there when the picture was taken? The photographer could have made the first shot of the beach with a wide-angle lens and a few hours later framed the rising moon with a telephoto.

The EOS 10 allows quite a few tricks of this kind. Just press the blue **FUNC** button to display **ME** for "Multiple Exposure" on the LCD panel.

All other displays disappear and the figure 1 appears at the top right of the panel. By turning the input dial you can determine how many exposures you want on one frame - up to nine. When the release button is lightly pressed the camera records this figure and film wind and frame count functions are inactivated.

When you release the shutter the film is exposed for the first time and the shutter reset ready for the next shot. The figure in the display panel will be reduced by one to tell you at any time how many shots remain for multiple exposure of one frame. If you decide to cancel this facility, press the **FUNC** button again and turn the input dial until the figure has disappeared. Releasing the shutter returns you to the previous mode.

Despite all the automatic exposure features the EOS 10 does need a little help from you. As a rule whenever the number of exposures is doubled the exposure is

halved, i.e. when two exposures are to be made on one frame the aperture either has to be closed by one stop or the shutter speed increased by one step. The best way is to leave the exposure control to the camera and to set exposure compensation according to the number of exposures. This is necessary as the correct exposure for each shot would result in the overall picture being overexposed. An exception must be made, however, when several subject parts are positioned in front of a dark background and each new subject would be exposed into the dark background of another. The exposure in this case is controlled for each subject part.

You need a good memory for multiple exposures as you will want to know where the subject is going to be positioned in the second and third shots of the frame. It might be an idea to draw a diagram of the scene when the interval between the various shots is several hours long. The camera's three focus fields might come in useful here.

A special kind of multiple exposure is *Doppelgänger* photography in conjunction with a suitable lens attachment. Cokin's Double Exposure device consists of a partly obscured disc which is inserted into the Cokin filter holder so it covers one half of the picture. First the person is photographed in one half of the picture. Then the disc is reversed and the second exposure made. Now one and the same person will appear in the picture twice, as a guest sitting at a table, perhaps, and as the waiter serving him. In this kind of photography the exposure must be metered before half of the picture is covered. Then shutter speed and aperture are set manually. It is also important not to change anything else in the picture as the join between the two picture halves might be visible.

The ME function is also useful when working with masks. The technical sequence is basically as in the

previous example.

The masks used must be perfectly matched. There are masks in the Cokin range with a circular black spot on a transparent background, another with a circular transparent spot on an opaque background. If these two, for example, are carefully inserted, a circular portrait could be shot and the second exposure could provide a frame of a landscape around it.

Apart from the range provided by Cokin you could design your own mask by using Cokin's creative masks. Cut out a hole in a piece of black foil and then place first the cut-out and then the hole on to a transparent carrier the same size as a normal Cokin filter which can then be inserted into a suitable filter holder. In this way a subject can be taken from its surroundings and placed into a quite different setting.

Interval Timer - Time-lapse Photography

Interval control units used to be great complicated boxes. They became smaller to fit onto the camera back. Now the Canon EOS 10 has its own built-in interval timer operated simply by pressing a button.

Interval photography was long regarded as something for the specialist, a scientist, for example, who needed to record the progress of an experiment. Therefore interval timers used to be very expensive.

But interval photography can be of great interest to the amateur, too. Try setting the EOS 10 on a stable tripod near a window and aim the lens at a line of roofs, including the sky and a few thick white clouds. Set the camera to shoot every 5 minutes. Using a 36-exposure film allows you to watch the formation of the clouds over a period of three hours. When you present these pictures during a slide show using the fade-in/fade-out technique the effect is almost like a time-lapse film show. In the same way you could photograph a flower unfolding its petals from bud to full bloom. Or study your movements when you sleep (make sure you do this in summer as heavy bedding might be obstructing and you should be sleeping so deeply that you are not woken up by the flash). And it is, indeed, possible to use a flash in the interval timer operation.

To activate the interval timer press the **FUNC** button at the back of the camera until the LCD panel shows **INT, 00:00:00** for hours, minutes and seconds, and the figure **1** for the number of exposures. Pressing the partial metering button sets the interval in hours,

minutes and seconds which start to blink in turn. Turn the input dial to set the desired number. Pressing the partial metering button for the fourth time sets the number of exposures you want to be made during the intervals selected. The timer is activated and the first picture taken as soon as you release the shutter. If you prefer not to shoot right away, press the self-timer before releasing the shutter.

Instead of the frame number, the LCD panel will now show the remaining time of the selected intervals and **INT** will flash. Shortly before exposure the EOS 10 automatically switches on its exposure metering and autofocus system and selects the values required. As long as AF mode ONE SHOT has been selected the frame will be shot even if autofocus is not possible.

Using the built-in flash during interval timer operation is no problem, either. It can be switched on prior to the first shot or at any time during the process. It will remain on stand-by until all the exposures are completed or until it is switched off. An external flash inserted into the camera's accessory shoe or connected to it by a suitable TTL control cable will remain switched on for the duration of the shooting series. Shortly before exposure it will be activated together with the metering systems by the camera. If the focal length of a zoom has been altered during the interval the reflector will be positioned correctly at this time, too. To save energy the flash will be switched off during long intervals and switched on again just before shooting. The timer is set in such a way, however, that the capacitor is fully recharged when the shot is made.

If the film is full before the last exposure has been completed the interval timer will be switched off. Taking more than 36 pictures is therefore only possible when the number of pictures is entered again after the film change. The interval data remain intact until they are changed.

Passing clouds are a good subject for interval shots.

The interval timer cannot be set in any of the symbol programs.

Motor Drive - No Film Waste

The motor on the Canon F1 - one of the classic professional cameras still loved and used - is powered by 12, 1.5v batteries and weighs in at 850g, to which the weight of the camera must be added. It winds the film up to five times a second. The total weight of the EOS 10 is 580g plus 40g for the lithium battery powering on its own the camera including the film wind motor. This motor also manages to transport up to five frames per second, i.e. exposing a 36-exposure film in less than eight seconds. With this function fast sequences can be separated into individual phases and captured. Sports or action sequences can be managed well with the high transport speed of the EOS 10. Continuous frame advance winds the film at a maximum of 5 frames per second only if no refocusing of each frame is necessary. The lens therefore remains set to the distance for the first frame when in AF-mode ONE SHOT. When AI SERVO mode is used, however, the fastest motor

"Go close to the subject and exclude everything that is unnecessary from the frame" is one of the most important rules for picture composition. In this case a close-cropped frame brings out the important colours.

frequency is automatically reduced to about three pictures per second leaving enough time between exposures to permit refocusing.

Five or three pictures per second - these transport frequencies can only be reached when the shutter speed is fast enough. It is best therefore to select shutter speed priority (**Tv**) and perhaps a high-speed film such as Ektachrome 400 or even Ektar 1000. Fast shutter speeds in this context are also useful to freeze the movement in the individual shots to illustrate a motion study.

To set the EOS 10 to continuous frame advance press the function button for the film-wind symbol to appear on the LCD panel and turn the input dial to set the desired mode.

Symmetry in the picture need not be boring. A good balance is created by the wide-angle perspective and a low shooting position.

Self-timer - Not Just for the Vain

Although the conspicuous whirring of self-timer mechanisms has nowadays been replaced by electronic controls the question still remains - is a self-timer really necessary?

The photographer's normal place is behind the camera which inevitably means he is never included in the holiday shots unless he passes the camera to a stranger to oblige. The self-timer therefore has its use - but it should be in conjunction with a tripod making it possible to adjust camera and lens to include all the desired subject. The small pocket-sized Cullmann Mini Magic II tripod is a good choice for such situations.

The self-timer is activated by pressing the self-timer button and then the shutter release. Autofocus and automatic exposure start at that point. If you want to take a picture just of yourself the lens has to be switched to manual focus and the estimated distance selected on the focus ring. To allow the exposure to be metered correctly, avoid standing in front of the lens. Also cover the eyepiece to prevent stray light from entering (the eyepiece cover located in the shoulder strap is provided for this purpose).

Once the release is pressed you have about 10 seconds to take up your position before the shutter is released.

The self-timer function is also useful to prevent camera-shake caused by pressing the release button in tele or close-up photography even when the camera is supported on a tripod. The mirror-up process can also

destroy a macro picture through camera-shake, which can be eliminated by Custom Function 13 in conjunction with the self-timer.

Pressing the self-timer button also activates the red LED light of the remote control receiver. The Remote Controller RC-1 is available separately and allows you to take pictures up to 16.4ft/5m away from the EOS 10 either immediately or with a two second delay. The release delay seems to be quite pointless at first but it can come in useful as there is no need to rush to your position after setting the camera and pressing the self-timer button. All you do is take up your position, release the shutter by remote control and have two seconds to hide the controller in your pocket. When all three focus fields are activated you can leave focusing to the camera which is another advantage of the remote controller over theself-timer.

If you want to take photographs without being noticed - children at play or animals feeding etc. - the remote control is useful again. A camera set on a tripod is hardly noticed and you can shoot just at the right moment. Program mode, evaluative metering and three active AF focus fields are all suitable to achieve good, remote-controlled pictures.

BULB - You Decide the Exposure Time

Although the **BULB** function is not one of the EOS 10's most important, exposures longer than 30 seconds would be impossible without it.

Select **M** on the command dial and keep turning the input dial to the left until the word **bulb** appears on the LCD panel and in the viewfinder.

The word "bulb" is a left-over from the times when the shutter of early cameras was opened with the help of an air pressure ball. When this bulb was compressed the shutter was opened, when the bulb was released the shutter closed again.

In a similar way the **BULB** setting on the EOS 10 allows the shutter to be kept open. The exposure time can be determined in advance using the camera's exposure meter, e.g. f/5.6 needs 30 sec, f/8 - 60 sec and f/16 - 240 sec, in theory anyway. In reality the longer exposures are affected by low intensity reciprocity failure which causes the film to be exposed to a lesser degree than expected from the exposure time set. Hence the exposure time must be corrected accordingly. Descriptions of films like Extachrome 400 recommend a plus compensation of 21/2 stops for exposure times of 100 sec. It might be an idea to keep to a certain type of film when such long exposure times are frequently used and experiment to find the required compensation factors for a specific exposure time.

In everyday - or rather every night - photography you are likely to select the **BULB** setting without

compensations. The Remote Controller RC-1 comes in very useful here. Press the control button once to open the shutter and again to close it. This corresponds to the **T** setting of older mechanical cameras.

Extremely long exposure times allow thunderstorms or fireworks to be photographed effectively. The use of a good stable tripod like the Titan series from Cullmann is recommended, however. Smaller tripods like those from the Magic series are useful for exposures beyond the hand-held limit.

By combining the **ME** function with the **BULB** setting you can close the shutter after the shower of stars of one firework and only open it again for the next rocket. In this way you can achieve several of these giant flowers of light in one picture without the background becoming too light.

A busy road is also an interesting subject for long exposures as is the night sky over an airport resulting in fascinating tracks of light.

If you can take your EOS 10 to a location not affected by light from other sources you could try tracking the course of a star in the night sky. First aim the camera upwards and open the shutter as soon as the first stars are visible. When the shutter is closed a few hours later the stars will appear to have more or less long tails on the picture - a result of the rotation of the earth. A variation on this theme is to aim the camera at the pole star, the stars will seem to encircle it in the final picture.

The fascination of the **BULB** setting is really based on two features. One is the ability to "collect" light to lighten a dark subject; the other is the facility of tracking light. Tracks are not only achieved inadvertantly like those of car or aeroplane lights - light tracks can also be contrived deliberately. Try positioning the EOS 10 on a sturdy tripod, attach a wide-angle lens and darken the room completely. Take

a torch and with it draw a picture into the air while the camera shutter is opened by the **BULB** setting, or track the contours of a subject with the torch which combined with flash can achieve fascinating results in nude photography.

The use of a torch is important in another **BULB** variation. Cover the light with a dark cloth or piece of paper leaving only a tiny hole, hang the torch from the ceiling and place the camera underneath equipped with a wide-angle lens . Completely darken the room and swing the torch around while the camera shutter is open - the result is a beautiful light pattern in the picture.

You might need to experiment a little with these kind of photographs - but that is half the fun.

Lenses - Canon's Decision

The ability to decide between a focused or unfocused exposure is not sufficient for a sophisticated AF camera. It must also allow the lens to be adjusted to the correct distance which requires a motor built into the camera or the lens itself. Most manufacturers of AF single lens reflex cameras decided to build the motor into the camera. Canon took the other path.

The autofocus motor in the camera has two valuable advantages - it only needs to be paid for once when the camera is bought and the lenses are focused by the camera, need no motor and can therefore be smaller and lighter.

Despite this, all Canon EF lenses are equipped with a focusing motor and there are certain reasons for this - as there is no power transfer from the camera motor to the lens a mechanical coupling is not required. Only commands and information are transferred between camera and lens. The lens motor can be located at the point where the lens elements have to be adjusted for focusing, i.e. the power is generated quickly and without loss during transfer. In addition the power generation can be designed to match the weight of the specific lens elements, while a motor built into the camera has to cope with all kinds of different lenses.

Although the Canon EF lenses are bigger than other AF lenses because of their built-in motor their weight or size are rarely detrimental. On the contrary - the lenses are very comfortable to hold. And Canon managed to keep their costs within reach of most

The difference between Canon's EF lenses and most other autofocus lenses is the built-in focusing motor.

The new Canon EF bayonet is larger than the FD bayonet and enables the fitting of faster lenses, especially useful to reporters, sports and animal photographers.

dedicated photographers. (The truly expensive lenses like the EF 80-200mm,f/2.8L or the EF 200mm,f/1.8L would be expensive even without a built-in motor).

Two different types of motor are used for the EF lenses; one is a small electronic motor transferring

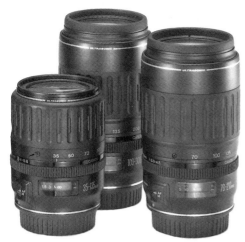

A Canon speciality; lenses with almost silent ultrasonic focusing motors. Here are three lenses of the second generation whose motors are noticeably smaller than those of the first generation.

power by means of a mechanical coupling to the movable optical elements and its whirring noise is quite distinctive. The other is an almost silent ultrasonic motor which drives a diaphragm not mechanically connected to the motor. The diaphragm movements are transferred to the focusing lens elements by ultrasonic waves.

The ultrasonic motors of the first generation were still quite hefty - look at the EF 28-80mm,f/2.8-4L. The introduction of the first three lenses equipped with ultrasonic motors of the second generation coincided with the arrival of the Canon EOS 10. These lenses are as slim as those with electronic motors and because the production costs of these ultrasonic motors are lower, they can now be fitted to average lenses like the EF 35-105mm,f/3.5-4.5 or the EF 70-210mm,f/4-5.6.

The Canon Range of Lenses - A Good Mix

It is the lenses that really make or break a camera - without a lens even as sophisticated a camera as the EOS 10 is only a light-tight container for the film. But Canon's wide range of lenses transforms this box into a true all-round camera.

Simultaneously with the arrival of the Canon EOS 10, four new EF lenses came on the market, three with ultrasonic focusing motors of the second generation, extending Canon's present range of autofocus lenses to 29 plus three converters.

Compared to the vast range of FD lenses for non-autofocus cameras the number of EF lenses seems quite modest as yet, but all the important focal lengths are available. The Canon lens program can be divided into three groups for different requirements.

Lenses with the "A" extension in their name are designed for use with the simpler EOS cameras and for newcomers to more complex cameras. The EF 35-70mm,f/3.5-4.5A and EF 100-200,f/4.5A lenses differ from more advanced models in that they cannot be focused manually and they lack a window with the distance scale.

At the other end of the range the lenses marked with "L" are equipped with specially ground optics or materials designed to give the very high performance not normally required in normal everyday photography. Professionals and dedicated amateurs should, wherever possible select an "L" EF lens rather than a normal EF lens, as the former perform better in

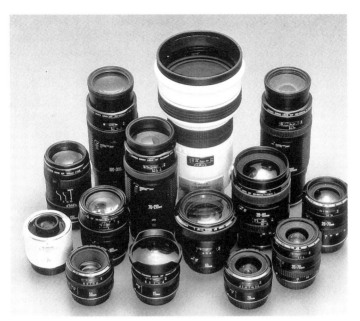

The Canon autofocus lens system ranges from fisheye to super telephoto and is being added to all the time.

border situations where many exposures are made with wide open aperture in bad lighting conditions. The more sophisticated lenses should also be used in conjunction with sophisticated films like Ektar 125, sophisticated tripods like the Cullmann Titan and a sophisticated projector with a good lens.

Of the nine "L" EF lenses available when the EOS 10 was introduced seven were ultra high-speed lenses.

The other lenses are ordinary lenses of very good quality and a speed suitable for a wide range of situations.

The three converters or extenders play a special part in the Canon lens range. Normally known as teleconverters the focal length increasing connecting

pieces between camera and lens are called extenders in the Canon system. These are special products designed for use with the high-speed, fixed focal length long focus telephotos.

The converter in the Canon system is designed for use with the 50mm macro lens which without converter can be set to an image ratio of 1:2, but with converter to a ratio of 1:1.

Fixed Focal Length or Zoom - Not a Problem

There are still some photographers around today who are convinced that good pictures can only be made with fixed focal length lenses whereas zooms would only lead to boring pictures and be second rate. It is time such prejudices were thrown overboard.

Twelve of the autofocus lenses in the Canon program are of fixed focal length, the other seventeen are zooms. Focal lengths have been designed in such a way that the range from super wide-angle to extra long telephotos can either be covered by fixed focal length lenses or by zooms. Fisheye, soft-focus or 600mm lenses should have fixed focal lengths, however.

The optical quality of the lens only partially determines which lens is chosen. Sharpness and contrast of fixed focal length lenses are only marginally better than in modern zooms. The advantages lie in the ability to correct vignetting and distortion effects. However, vignetting is less of a problem when the lens is stopped down and distortion only becomes apparent when there are indeed straight lines running along the edge of the picture. And to be honest, these problems are only noticeable to the person actively looking for them.

The advantages of zoom lenses are versatility, creativity and comfort.

Instead of a pocketful of lenses the user normally carries only one or two zooms which rarely need changing. To alter the focal length the zoom ring simply needs to be adjusted.

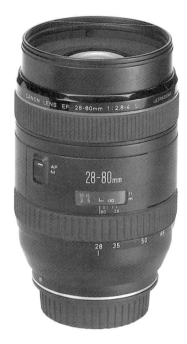

(above right)
Canon EF 28mm,f/2.8 - an all-round wide-angle lens

(above left)
Canon EF 28-80mm,f/2.8L USM - it offers all wide-angle focal lengths and extends to the portrait telephoto range.

(right and below)
Canon EF 35-105mm,f/3.5-4.5 and Canon EF 100-300mm,f/5.6 - a versatile zoom combination

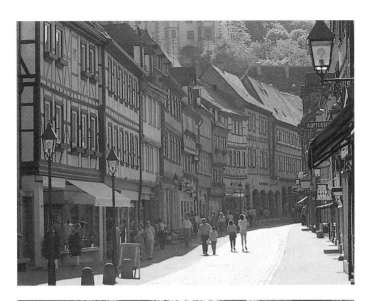

Overall views and pictures picking out detail are made possible by a zoom without having to change the lens.

This simple zoom operation also allows the extent of the frame to be determined when the shot is made. The frame is fixed by the shooting position and the focal length. It is the shooting position that determines the perspective. The subject cannot be increased or decreased in size simply by going closer to or further away from it - this can only by achieved by altering the focal length, which the zoom allows through a wide range.

Equipped with a telephoto and a zoom, spanning the wide-angle to short tele range, you should be able to face any subject - be it a landscape or the fretwork detail on a historic building. And thanks to the macro setting provided with all Canon zooms you can get involved in close-up photography as well. Good lens combinations are EF 28-70mm,f/3.5-4.5IIplus EF 70-210mm,f/4; EF 35-105mm,f/3.5-4.5 plus EF 100-300mm/4.5-5.6 USM or - if you want to treat yourself - the combination EF 28-80mm/2.8-4/L USM plus EF 80-200/2.8L USM, a pair that can be extended by the EF 20-35mm/2.8L USM at a later date.

To specialize in certain subject areas a basic set of two zooms and a suitable fixed focal length special lens is recommended. The EF 50mm,f/1.0L and EF 85mm,f/1.2L are suitable for documentaries, the EF 200mm,f/1.8L and EF 300mm,f/2.8L (plus extender EF 2X) for sports photography, and for close-ups the EF 50mm,f/2.5 Macro (plus actual-size converter) or EF 100mm,f/2.8 Macro are ideal to supplement the zooms.

Lenses and f/numbers - How Important are They?

The technical data of lenses always include information regarding their design as well. The values are usually included in the lens name. But how important are they for practical purposes?

The number of optical elements of a lens is no indication of its performance. A fixed focal length wide-angle lens like the EF 28mm,f/2.8L has five elements whereas the EF 100mm,f/2.8 Macro consists of ten elements in nine groups and the high-speed EF 28-80mm,f/2.8-4L zoom has fifteen elements arranged in eleven groups.

The number of elements changes according to the purpose of the lens. When special lenses are made of a certain material or in a particular shape (aspheric lenses) with fewer elements they can offer a superior performance compared to a lens of equal focal length with more elements.

When buying a lens for your EOS 10, the number of elements is irrelevant; its speed and focal length are of the utmost importance, however.

What does speed mean? The lens aperture can be opened to a specific degree. The largest opening is usually the f/number accompanying the lens name, i.e. 1.8 or 3.5 denote the number of times the diameter of the largest opening can be divided into the focal length. The smaller the number the larger the opening through which the light can reach the film and the faster the shutter speed. A lens with an f/number of 1.8 is therefore faster than one with f/4.

Short focal length and distance, camera pointed upwards - converging verticals are unavoidable but give a sense of height.

Canon EF 50mm,f/1.0L USM, Canon EF 85mm,f/1.2L USM - incredibly fast but suitable only for specialists.

Like the speed, every normal aperture value also gives the number of times the opening can be divided into the focal length, i.e. for aperture f/4 the opening must cover 12.5mm for a normal 50mm lens, in a 200mm lens the value is 50mm. The amount of light

reaching the film is the same in both cases.

Calculating the size of the aperture to provide a speed of 1.8 - that is nearly 28mm in the case of a 50mm lens, over 11cm in a 200mm lens - it becomes clear that equal speed of different focal lengths must be evaluated differently. Although the same amount of light reaches the film, the EF 50mm,f/1.8 is quite an ordinary lens whereas the EF 200mm,f/1.8L is a very high-speed telephoto lens. To achieve high speed for normal lenses the maximum aperture must be considerably above 1.8 - which Canon managed to do with their EF 50mm,f/1.0L, a lens offering the highest speed of all SLR lenses on the market and the EF 200mm,f/1.8L is the leader in its class. The entire selection of Canon lenses with their high speed is very attractive indeed. But when it comes to costs the question arises, whether such high speeds are really worth it.

Well, for a start the viewfinder image is brighter. Although that might not be so important in an autofocus camera it does make it easier to evaluate the subject at dusk or inside.

The multiple zone evaluative metering of the Canon EOS 10 is very efficient, but occasionally an exposure series controlled automatically via the AEB setting can achieve correct exposure more effectively. Seen here are the darkest and the brightest pictures of a series of three.

A fast lens can also be used hand-held without flash in poor light. Where the wide open aperture of the EF 100-300mm,f/5.6 requires a dangerous 1/125 sec, the camera can select 1/500 sec when the EF 300mm,f/2.8 is used. The use of such large and heavy lenses requires some practice and strength, however.

Thirdly, a slower film can be used with high speed lenses which allows exposures at equal brightness and shutter speed when the aperture is opened a further one or two stops. Thus the fine grain and sharpness of Kodak Ektachrome 50 HC can be used in poorer light than with a slower lens.

A fourth advantage of high speed lenses is the facility to separate subject and background better because the depth of field is narrower. But this advantage could turn into a disadvantage; when trying to utilize the high speed only a small part of the subject appears in focus and all the rest is blurred.

And talking of disadvantages; not only are the high-speed lenses very expensive, they are large and heavy as well.

Graphic subjects with limited colour should be tightly framed from as close as possible (above).
Even a still life can be given movement by a wide-angle lens. In such cases partial metering might be suitable (below).

When a wide-angle is used the whole merry-go-round can be included in the picture.

The upshot of it is; when you have to rely on being able to work in the lowest possible light without flash and possibly without tripod the investment in a high-speed lens is one well made. If you simply enjoy your hobby, a normal EF lens will do very nicely. If necessary take a small tripod along and ISO 400 film for exposures at dusk or dawn. Be advised, however, not to skimp on a tripod. High-speed lenses require proper support and a small tripod like the Cullmann Magic II still works out cheaper than the difference between an EF 70-210mm,f/4 and an EF 200mm,f/1.8L.

Wide-angle - More than Just a Bigger Picture

When asked the reason for buying a wide-angle lens many a person will say, to increase the picture, which is what a wide-angle can do, of course. But that is not all.

Normal focal length is regarded as 50mm and all lenses shorter than this are called wide-angles. The larger the angle the shorter the focal length, i.e. the wide-angle will include more of the subject than a normal lens.

The choice of a wide-angle is always the right choice where there is not enough space for exposures with other lenses. Architectural photography is often impossible without a wide-angle. When shooting the interior of a building, for example, it is important to hold the camera as level as possible without including too much unnecessary foreground. If the camera is held at too steep an angle vertical lines like columns in the picture will appear to converge. It is therefore important when shooting in confined spaces to reach a compromise between too much foreground and converging verticals. It might be possible to enliven the foreground to make it an important part of the frame - step aside a bit to include that little dog just passing in front of the magnificent cathedral. Another solution is not to compromise but to include converging verticals as a virtue. Walk closer to the subject, crouch down and point the EOS 10 with its wide-angle steeply upwards. The falling lines will now add interest to the picture by illustrating the height of a building.

Wide-angle lenses are perfect for landscape

The Canon EF 24mm,f/2.8 - sooner or later this lens becomes a "must" for a wide angle of view.
The Canon EF 20-35mm,f/2.8L - a zoom covering the range from super wide-angle to wide-angle and offering a large maximum aperture.

photography as well. The scale of a dramatic mountain range is beautifully illustrated by the use of a wide-angle lens. Where there are no vertical lines in the subject, holding the camera upwards or downwards to alter the content of the picture presents no problem. When the camera is pointed upwards an enormous sky spans the picture, downwards and the atmosphere becomes closer and more compact.

Sharpness from front to back is of great importance in this kind of photography. The icon program "landscape" is of great help here, but **DEP** is very suitable, too.

Wide-angle lenses are not only attractive for

Canon EF 28-70mm,f/3.5-4.5II - in conjunction with the EF 70-210mm,f/4.0 - are a very versatile pair (left). Canon EF 35-135mm,f/4-5.6 USM - a useful zoom because of its long range and very quiet motor (right).

landscapes or interiors. Ordinary subjects can be given a lot of interest when shot with such alens. The wide angle can be utilized to create a relationship between the main subject and its surroundings. The steep perspective is useful to manipulate the scale of a subject. Shot from close range and from below, an ordinary car can be turned into a luxury limousine.

The Canon range of autofocus lenses includes two fixed focal length wide-angles, the EF 24mm,f/2.8 and the EF 28mm,f/2.8, both very suitable to complement a two zoom system.

Two zooms, EF 28-70mm,f/3.5-4.5II and EF 28-80mm,f/2.8-4L start at a focal length of 28mm and

Canon EF 15mm,f/2.8 - a fisheye lens with an angle of view of 180° across the diagonal.

there are five other zooms with focal lengths of 35mm: both the EF 35-70mm,f/3.5-4.5 in the standard version and as an A version without focus ring, the EF 35-105mm,f/3.5-4.5, and the EF 35-135mm,f/3.5-4.5 which will have difficulty holding up against the slower EF 35-135mm,f/4-5.6 USM equipped with a fast, quiet ultrasonic motor.

A standard wide-angle lens today has a focal length of 28mm and a 35mm lens could almost be classified as a normal lens with a larger angle, as it approaches the picture as we see it with both eyes more closely than a 50mm lens.

A very special lens among the Canon wide-angle zooms is the EF 20-35mm,f/2.8L as it has a range from only 20mm right into the super wide-angle area and with its speed of 2.8 is also very powerful.

A lens with an extensive angle is the EF 15mm,f/2.8 although it is not truly a wide-angle. The angle of 180°

Curved lines caused by a fisheye lens can be quite effective.

achieved diagonally across the frame classifies it as a fisheye lens. It is characterized by the fact that the barrel-shape distortion is not corrected - straight lines not crossing the centre are noticeably distorted towards the edge of the frame.

Standard Lenses - Better than their Reputation

The conventional 50mm standard lens has been overshadowed by the small zoom lenses ranging from wide-angle to telephotos. But a focal length of 50mm can be used for a wide range of interesting photographs.

The most powerful standard lens for 35mm SLR cameras is the Canon EF 50mm,f/1.0L. But only its focal length indicates it as "standard". The brightness and clarity of its viewfinder image is normally only found in optical viewfinders but as the EOS 10 is a camera with open aperture metering the bright viewfinder image always shows the subject in the narrow depth of field of f/1. This is fine for exposures at dusk when a high speed lens is advantageous. During the day, however, it might be better to select depth of field check through Custom Function 11. Utilization of the high speed requires careful focusing. Although this is controlled by the AF system the photographer must decide which subject part should determine the evaluation. Activation of the central focus field is recommended.

The second AF standard lens in the Canon range is the EF 50mm,f/1.8. It lies about 12/3 stops below the EF 50mm,f/1.0L and is quite sufficient unless you intend to shoot frequently at dusk, in badly-lit pubs or without flash at the theatre. The angle of this lens corresponds broadly speaking to the human eye although the 35mm lens depicts the image seen with both eyes.

142

Canon EF 35-70mm,f/3.5-4.5 offers focal lengths around the standard value.

The 50mm lens, although standard, need not be boring. It is a standard lens because it is so versatile. Buildings can be shot without problems of converging lines, portraiture is possible without distortion caused by wide-angles or flatness caused by telephotos, landscapes appear without sun reflection, snapshots are easy without the need to approach the subject closely or without searching around a long time, because the angle is too narrow for a telephoto.

The standard lens is suitable for a wide range of subjects - just try it out!

Telephotos - For Close-ups As Well

Apart from the obvious function of photographing a subject from a distance the telephoto lens has a great deal more to offer.

The area of long focal length can be divided into three parts: one is for portraits with focal lengths of about 70mm to 135mm, then follow the normal telephoto focal lengths of about 135mm to 250mm and finally there are the super tele focal lengths from 300mm.

The Canon EF lenses are available in all three areas and several zooms exceed these limits, which are very flexible in any case.

The focal length area for portraits allows a good perspective - neither too steep nor too flat. Lenses around 85mm are a good choice as the background can be blurred when the aperture is fully opened.

The EF 85mm,f/1.2L is an excellent lens for this type of photography. The addition of a quiet ultrasonic motor makes portrait photography a real pleasure.

The Softfocus EF 135mm,f/2.8 is also useful for portraiture. As this lens features a setting ring for two different soft-focus settings the sitter can be depicted in a flattering way. Setting **1** is for a very slight soft-focus, in setting **2** the soft-focus effect is quite noticeable. When set to **0** this lens is an ordinary medium telephoto providing good sharpness and contrast.

All the focal lengths of between 85mm and 135mm including Canon's EF zooms are useful for all kinds of other things as well.

The converging verticals in this wide-angle picture are irritating, and so is the careless framing of the house. If a telephoto was used from a greated distance these problems would not occur.

147

Canon Softfocus EF 135mm,f/2.8 - a special lens for soft-focus effects in pictures, but at the same time a medium range telephoto suitable for all kinds of situations (left).
Canon EF 35-135mm,f/3.5-4.5 - an all-purpose zoom lens. The choice lies between this and the only marginally slower USM lens of equal focal length range (right).

Still life photography can be achieved very well with lenses of a focal length of 70mm as - unlike a wide-angle - distortion is not a problem here. Of course, these lenses must be stopped down considerably to achieve the necessary sharpness for still life. The use of Custom Function 11 is recommended here.

In landscape photography medium telephotos are useful to separate certain characteristics of the

landscape from the surroundings.

This also applies to the normal telephotos represented in the Canon system by the fixed focal length EF 200mm,f/1.8L and several zooms - two 50-200mm lenses, two variants of the 70-210mm, one 100-200mm in variation A without focusing ring and last but not least the rather expensive EF 80-200mm,f/2.8L. Also part of this group are three100-300mm zooms.

When telephotos are used in landscape photography the aperture should only be opened fully when details like a solitary tree or an interesting rock are to be included. Otherwise medium or small apertures are to be recommended in order for the depth of field to embrace as large an area of the landscape as possible. To prevent camera-shake blur with the smaller apertures the camera should be supported or a tripod used. Apart from the EF 80-200mm,f/2.8L no other lens in this group has provision for a tripod fitting. Hence a solid, stable tripod like one from the Cullmann Titan series should be used here. When attaching the camera to a pan and tilt tripod make sure that the lens does not drop forward. A macro slide could help here. Insert

All the focal lengths from standard to telephoto in one zoom.

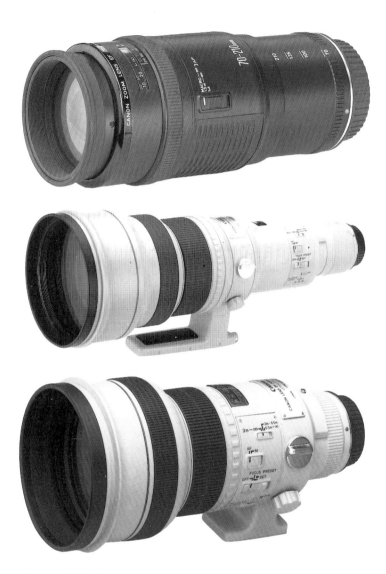

Canon EF 70-210mm,f/4 - a classic tele zoom with macro setting. Ideal in conjunction with a 28-70mm lens (above). Canon EF 300mm,f/2.8L USM-for all kinds of action shots. A tripod is recommended (below). Canon EF 600mm,f/4.0L USM - a high-speed super telephoto for specialists (centre).

150

your EOS 10 with its long lens onto the slide and then mount both on the pan and tilt head. Now the camera can be moved backwards until the point of gravity of the whole unit lies over the tripod top. The downward move of the lens can thus be eliminated. This way I was able to stabilize the EOS 10 plus the EF 100-300mm,f/5.6L at longest focal length on the Cullmann Mini Magic II, although the central column was not fully extended.

Very often, landscape photography looks different in the picture from what you saw through the viewfinder. The reason lies in air currents which, particularly in summer can affect the result considerably. A good time to use a telephoto lens is after a thunderstorm or heavy rain as the air has been cleaned and the colours are intensified. A suitable film here would be Ektachrome 100 HC.

The super telephotos with focal lengths from about 250mm onwards are represented in the Canon range by the three 100-300mm zooms. In addition there are the EF 300mm,f/2.8L and the 600mm,f/4L, both of which can be turned into even longer telephotos by the extenders specially designed for them. The 300mm becomes a 600mm lens with a maximum aperture of 5.6 and the 600mm becomes a 840mm lens also with a maximum aperture of 5.6.

Of course, super telephotos are ideal for sports, action and animal photography as they permit a suitable distance from the subject.

A 600mm lens is also eminently suitable for landscape photography. When the sun sets as a red ball of fire a normal lens cannot show it larger than a pin point, a 300mm lens can depict it about the size of a peppercorn, but in a picture taken with a 600mm lens the setting sun will be about 6mm in diameter which is nearly a quarter of the picture. The concentrating, flat perspective of telephotos also comes into effect in

landscape photography . Mountain ranges far apart appear closer together.

The perspective of long telephotos can be used in other areas as well. People on the beach seem to be packed closer together than they really are. Or try separating a beautiful small item from its boring surroundings; a rather ugly market stall and a lovely bright basket of apples. The longer focal length of the tele zoom can bring out just the apples.

Macros - Great for Small Subjects

One of the most popular subject areas is macro photography. There are various ways to fill the frame with a very small subject and a fine thing for close-up photography is an auto macro lens.

Although with Canon's AF zooms some good macro shots can be achieved, these lenses are not really designed for close-ups as their true purpose lies in

The macro setting of a zoom is sufficient for unpremeditated close-ups. A macro lens is indispensible when you need a greater image scale.

Canon Macro EF 50mm,f/2.5 - a
compact macro lens which can be
focused to a reproduction ratio of 1:2
without converter.

pictures at a distance of many metres.

A photographer fascinated by the world of little things has the choice of two Canon macro lenses, the Compact-Macro EF 50mm,f/2.5 which will give an image ratio of 1:2 and 1:1 with a converter. The Macro EF 100,f/2.8 can be focused to a ratio of 1:1 without a converter. The subject here is only 31cm away from the film plane - on which all distance settings in connection with lenses are based.

Both these lenses are designed to provide equal performance across the whole range of distances - from infinity to less than 23cm or 31cm respectively. The Compact-Macro EF 50mm,f/2.5 is therefore also a high-quality normal lens and the 100mm a high-quality telephoto.

There might be certain problems arising when

Modern functional buildings like a theatre are just as suitable a subject as an arcade. Whereas the fountain in the foreground (above) provides some interest, the solitary bicycle (below) counteracts a somewhat dull symmetry.

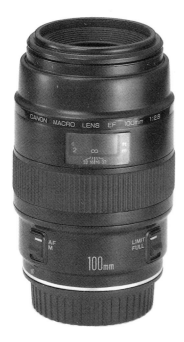

Canon Macro EF 100mm,f/2.8 - the longer focal length offers more favourable shooting distances when photographing small animals. Illumination of the subject is also easier than with the 50mm. In addition, no converter for pictures with a ratio of 1:1 is required.

shooting at close range and with a large reproduction ratio. Because the camera needs to be very close to the subject a copying stand and camera slide can be of great help here. And to illuminate the subject properly, which might be difficult because of the closeness of the lens to the subject, the use of a ring flash like the Canon Macro Ring Lite ML-3 is ideal. But as the expenditure on such a flash is perhaps not always justified two reflectors made of polystyrene and a photographer's light can achieve quite a lot, especially when used with Kodak Ektachrome 160.

The weather need not always be bright and beautiful to take good pictures. The contrast between sunshine illuminating the house front and gathering clouds can be very attractive. The streetlight, brought into the picture by the embrace of the wide-angle lens, adds interest to the foreground.

Canon Life-Size Converter - increases the range of the Macro EF 50mm,f/2.5 to a reproduction ratio of 1:1.

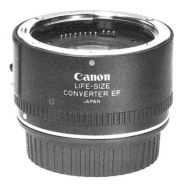

A camera slide simplifies macro shots.

Whereas a macro lens provides the most sophisticated solution for macro photography, supplementary lenses are a good introduction to this activity. Canon's close-up lenses 240, 450 and 500 T can be attached to EF lenses.

Graphic composition gives interest to macro shots, as illustrated by the smooth edges of this leaf.

Extenders - Two from One

The use of extenders or converters is not always the cheapest way to turn an average telephoto into a below average super tele. Canon extenders for EF super telephotos can cost more than the lens itself but they do offer a lot.

Modern lenses are the result of lengthy computer calculations. The shape of the lens, its strength and materials have been carefully designed to provide the best image reproduction on the film. Even a filter can reduce the optical performance of a lens. How much greater is the influence of a whole group of lenses on the path of the light to the film. To alleviate this reduction in performance Canon brought out its two extenders for use with the EF 200mm,f/1.8L, the EF 300mm,f/2.8L and the EF 600mm,f/4L.

Extender EF 2X doubles the focal length which involves a loss of two aperture stops. The TTL metering takes account of this and there should not be any exposure problems.

Extender 1.4X only involves the loss of one aperture stop and the EF 600mm,f/4L becomes an 840mm telephoto, for example.

Both extenders are not simply additional lenses attached to the lens but they were included in the calculations for super telephotos from the beginning. The performance should therefore be only marginally reduced.

In view of the different control signals no problems should arise, either. Both autofocus and aperture

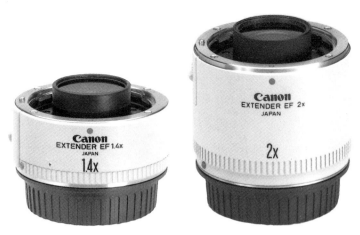

Canon Extender EF 1.4X - turns an EF 600mm,f/4 into an EF 840mm,f/5.6 (left).
Canon Extender EF 2X - for the high speed 200 and 300mm lenses (right).

control work as before. Both of Canon's super telephotos are equipped with focusing limiters enabling you to decide whether the lens should run through the entire range from infinity to macro or whether it should limit itself to certain ranges.

Flash - Four Important Points

There are four common questions that always crop up in connection with the use of flash.

First question: What is the meaning of the flash factor or guide number and how can it be converted to the different film speeds?
Answer: The guide number is related to the intensity of the flash. The higher the guide number the further the flash reaches with a given aperture or the more the aperture can be closed for a given distance. The calculation formula is as follows:

guide number (ft) = aperture x distance (ft).

From this the formula to calculate the aperture and illumination distance can be derived thus:

aperture = guide number (ft) : distance (ft)
illumination distance (ft) = guide number (ft) : aperture.

The guide number always depends on a specific film speed, usually to ISO 100/21° because this film is very popular. The guide number increases with the film speed. Each film speed level - i.e. from ISO 100/21° to ISO 200/24° and from there to ISO 400/27° represents a guide number increase of X1.4. Starting from a film speed of ISO 100/21° the guide number can easily be calculated by using the aperture stops 1.4 - 2 - 2.8 - 4 -

5.6 etc. as a base. There are three steps from ISO 100/21° to ISO 800/30° the guide number must therefore be multiplied by 2.8. To convert to slower film speeds simply divide instead of multiplying. The guide number of an ISO 25/15° film is thus only half that of an ISO 100/21°.

The guide number also depends on the illumination angle. The more concentrated the light the further it reaches. As the illumination angle is only important in connection with the angle of view of the lens and therefore the focal length it is usually given for a specific focal length. Normally a focal length of 50mm is assumed, but longer focal lengths are common, too. To convert the guide number from one focal length to another again X1.4 is used to double or halve the focal length.

Second question: Why is the use of indirect flash recommended and how can it be achieved?
Answer: The light from a flash is rather harsh. Its shadows are hard and spoil the picture. When the flash is used indirectly, i.e. when its light is reflected from another area rather than the subject, shadows become softer and the light is diffused. To use indirect flash the flash unit must have a reflector that can be directed to a wall or ceiling from which the light can bounce back. If no suitable reflection area is available additional reflectors like the LumiQuest provide a good alternative. The larger models Ultrasoft and BigBounce can be covered with diffusing foils giving an even softer light.

Third question: What is the reason for the "red eye" effect?
Answer: When people are photographed in a dark room the pupils of their eyes are wide open. The flash is reflected from the blood vessels in the retina. This

usually happens when the flash is too close to the axis of the lens. By using a flash indirectly or moving it to one side with a synch lead this effect can be avoided.

Fourth question: What is the purpose of synchronization speed?

Answer: Like all 35mm SLR cameras the Canon EOS 10 is equipped with a slit shutter. When the first and second shutter blind start one after the other the resulting slit passes in front of the film. The flash usually occurs when the first blind uncovers the film. If at that time the second blind is already moving because a fast shutter speed has been selected the short flash is caught by the second blind and cannot reach the film. The flash can therefore only be used with shutter speeds that start the second blind after the first has uncovered the film completely. The fastest shutter speed to allow this happening is the synchronization speed. In the Canon EOS 10 this is 1/125 sec. When a system flash is used any faster shutter speeds selected are automatically switched to 1/125 sec. Of course, the flash can also be used with slower speeds although the ambient light might influence the exposure.

Built-in Flash - Sunlight not Required?

The built-in flash has become a popular feature of many cameras. The Canon EOS 10 is no exception.

This camera is not the first SLR camera with built-in flash but the first in its class to feature it.

The flash is hidden in the camera's viewfinder mounting and is not noticeable during the day. When required, the flash can be activated in automatic control

A backlit subject very often turns into a silhouette. This can be prevented by the use of a fill-in flash.

or manual exposure mode by pressing the button. In the icon programs the EOS 10 activates the flash automatically only when lighting conditions or other factors require its use.

The built-in flash of the Canon EOS 10 with its guide number of 12 is like others of its kind not particularly powerful. The greatest illumination distance is, according to the technical data, 4.3m but this also depends on the state of the battery which powers it as well as all the other camera functions. Although the guide number increases with a faster film the strength of the flash remains the same despite the increase in range. Whenever an external flash unit is inserted in the accessory shoe the built-in flash is inoperative.

An important point in connection with the built-in flash is its ability to lighten the shadows. As the film in limited to a certain amount of contrast the shadows can appear quite dark in the picture. The built-in flash can brighten the shadows in such situations resulting in a good balance of contrasts.

The camera meters the amount of light from the flash and controls its duration accordingly. During evaluative metering the flash exposure like normal exposure is determined by the subject area focused on. TTL metering also takes place when the built-in flash is used. In aperture priority (**Av**) mode the use of a tripod is advisable. Otherwise the synchronization speed can be fixed to 1/125 sec using Custom Function 9.

The Flash Program - Money Well Spent

Including a flash function in the camera controls brought many advantages to the user. Canon pointed the way with its AE-1 but included the TTL control rather late with the T90. Today Canon's range of flash units is quite impressive.

Three Canon flash units have been specially designed for use with the EOS 10; the Speedlite 300 EZ, the Speedlite 430 EZ and the Macro Ring Lite ML-3, as well as the older Speedlite 420 EZ. Although other flashes are usable with the EOS 10 the autofocus will not be operative.

The Speedlite 300 EZ is attached to the camera via the accessory shoe and its head cannot be moved. But the camera can adjust the illumination angle to the focal length of the lens by turning the reflector. As soon as another lens is attached the reflector will be readjusted in four steps for focal lengths of 28mm, 35mm, 50mm and 70mm and intermediate values. The flash factor or metre guide number of the Speedlite 300 EZ is 28, ISO 100/21° and focal length 50mm.

The flash is controlled by Canon's A-TTL (Advanced Through The Lens) metering whereby an AF Illuminator checks if subject and background is within range for correct focus and exposure. Manual use of flash is possible by selecting **M** on the command dial of the camera.

The use of the larger and more powerful Speedlite 430 EZ in connection with the EOS 10 is recommended as its many features are supplemented very well by this flash.

One of the effects is the synchronization with the

second blind. The flash only occurs just before the second blind closes the film window. Moving subjects are depicted blurred and frozen by the flash.

The Speedlite 430 EZ also features a stroboscope facility allowing movement sequences to be separated into individual phases.

The flash performance can be reduced for fast exposure sequences and flash exposure compensations in the area of +/- 3 stops are possible. This is a vital difference to the otherwise very similar Speedlite 420 EZ.

Unlike the 300EZ and the 420EZ the Speedlite 430 EZ can be powered from an external source allowing more pictures to be taken quicker.

Both the Speedlite 420 EZ and the Speedlite 430 EZ feature an adjustable flash head, an important advantage over the Speedlite 300 EZ, as this facility allows well-lit pictures not spoilt by hard shadows and flat lighting.

The illumination angle of the Speedlite 430 EZ can also be adjusted manually. A wide-angle flash can be used in conjunction with a telephoto lens so that the light from any objects surrounding the subject is reflected, diffused and thus softened. The zoom area of this flash unit ranges from 24mm to 80mm.

As with the other flash units an AF Illuminator determines whether the subject is within the range of the flash - but only if the subject is illuminated directly. If the reflector is moved for indirect flash, metering by the AF Illuminator would be inaccurate so it is not activated. Instead both 430 EZ and 420 EZ send out ordinary flashes at a reduced output of about 20% to calculate whether the range of the flash is sufficient for the subject. If the subject is out of flash range the aperture value in the viewfinder will start to flash.

The amount of information given by the Speedlite 300 EZ is limited to the ready-light and the focal length

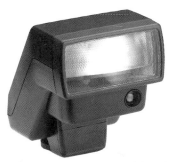

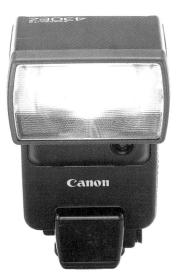

Canon Speedlite 300EZ - although the flash head is fixed it is still a useful and easy flash to use because of its A-TTL and TTL control (above left). Canon Speedlite 430 EZ - a versatile flash unit with moveable head useful for work with soft, indirect lighting (right).

to which the illumination angle of the zoom reflector is adjusted. Both 430 EZ and 420 EZ feature an illuminated LCD panel giving a lot of information from the operating mode used to the range of the flash and in manual mode from the illumination angle to the flash performance.

All three flash units are equipped with a fast recycling function indicating when the capacitor is partly (green light) or fully (red light) charged. The three Speedlite EZs also feature an energy saving switch-off facility whenever the flash has not been used for a certain time. The switch-off time for the 300 EZ and 420 EZ is five minutes, that of the 430 EZ is only 90 seconds. To reactivate the unit simply press the shutter release or the ready light of the flash unit.

All Speedlites store any energy not used for a flash for the next operation resulting in very fast recycling times.

If you have to chose between the Speedlite 300 EZ and the Speedlite 430 EZ it is always better to go for the

169

larger model as it is more powerful and has more features to offer. You can continue to use an existing Speedlite 420 EZ but when you think of replacing it go for the Speedlite 430 EZ.

The Canon Macro Ring Lite ML-3 is a flash designed for macro photography. Unlike other flash units its control and power unit is separate from the ring-shaped flash head which can be attached to the lens. This flash unit works very well when used in conjunction with Canon's two macro lenses. The source of light are two flashes which when both switched on illuminate the subject almost without shadow - an important feature when a lot of detail has to be included. Shadows, however, are useful to give a three-dimensional effect. Both flashes can therefore be operated independently and turning the flash head as well allows quite good light control. Additional reflectors of polystyrene or aluminium foil can also be used.

Like the Speedlites the Macro Ring Lite ML-3 is also controlled by the camera.

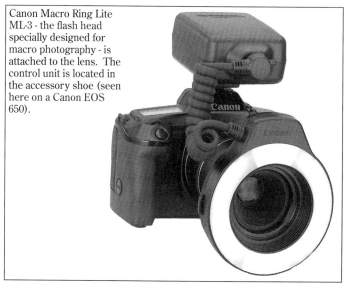

Canon Macro Ring Lite ML-3 - the flash head specially designed for macro photography - is attached to the lens. The control unit is located in the accessory shoe (seen here on a Canon EOS 650).

Speedlites - Simple, Clever, Safe

Often a flash is nothing more than a weak substitute for the sun whose light would be sufficient anyway. Canon Speedlites can do more than provide additional light.

TTL control alone is a great help to the photographer. The flash light falls on to the subject, is reflected into the lens and passed on to the film. During exposure a small amount of light is directed to a sensor. As soon as the film has received sufficient light the flash is switched off.

TTL metering is based on the amount of light allowed to pass to the film through the lens aperture. Thus flash exposure is determined by the aperture and light duration of the flash. The synchronization speed does not influence the exposure by flash.

This is how flash exposure operates when the EOS 10 is manually set to a synchronization speed of 1/125 sec.

When a slow shutter speed is selected, and it is not completely dark, the film is also exposed to the ambient light reaching it through the open shutter. This is the reason that it is possible to expose a picture with the light from a flash and normal light and to combine both light sources effectively. This is rather a complicated procedure which is why Canon simplified it by including the A-TTL flash metering.

The flash exposure is adjusted to the main subject the camera focuses on. When the choice of AF focus fields is left to the camera or you have selected one of the two outer focus fields manually, the flash also

reaches a subject not found in the centre of the picture. According to the operating mode selected the EOS 10 determines the exposure of the surroundings.

In the combination A-TTL plus aperture priority the camera selects a synchronization speed of between 1/60 and 1/125 sec according to the ambient light and a suitable aperture which in turn controls the flash exposure. Depth of field AE and camera-shake alert are downgraded to ordinary program functions when a flash with A-TTL is in operation.

Turning the command dial to **M** switches the flash mode from A-TTL to TTL. The main subject illuminated by the flash is exposed correctly but illumination of the background is determined by the manually-set shutter speed and aperture.

In conjunction with the Green Zone and the icon programs the flash is used as a program flash while shutter speed and aperture are controlled by the camera. When one of the bar code programs has been chosen a flash should only be used when recommended by the bar code booklet.

All this applies to both the Speedlite 300 EZ and the Speedlite 430 EZ.

It is not possible to switch to manual operation on the 300 EZ. When the EOS 10 is set to **M**, flash exposure is controlled automatically according to the aperture selected.

Manual operation can be selected with the 430 EZ by pressing the AF Mode button until **M** and 1/1 appear in the LCD panel of the flashgun. When the capacitor is charged and the shutter release pressed the display also shows the illumination range of the flash. This display changes when the focal length of the lens is changed and the zoom reflector is altered. The focal length of the zoom reflector is also shown. This also applies when the zoom reflector is adjusted manually.

For manual operation of the 430 EZ the EOS 10 must

also be set to **M**.

It might appear quite pointless at first to select manual operation of both the flash and the camera when good results can be achieved quicker and safer automatically. Only when you press the "+" or "-" button and reduce the flash performance to 1/2, 1/4, 1/8, 1/16 or even to 1/32, does manual operation makes sense. Reduced flash output allows very short exposure series of five frames per second. Here an external battery pack is highly recommended. The distance and length of the series depends on the charge of the power pack, the speed of the film used, the aperture selected and the chosen output level of the 430 EZ.

In AF AI-SERVO mode the motor automatically switches back to three frames per second and you can expect more flash exposures in a series as the flash has more time to recharge.

Speedlite 430 EZ - Extra Performance

The Canon Speedlite 430 EZ is a flash unit with a complex range of quite unexpected features for its class. One of the features is its stroboscope facility which involves a succession of flashes to capture several movement phases. To achieve the greatest effect from this facility this type of exposure should be made in as dark a room as possible.

Ensure that both the EOS 10 and the Speedlite 430 EZ are switched to manual. The shutter speed must be slow enough to allow the flash to light up several times, at least 1 sec or preferably longer. The aperture setting is governed by the required flash range and is displayed on the flash unit's LCD panel.

Press the mode button on the 430 EZ until **M, 1/16, MULTI** and **1 Hz** are displayed in addition to the aperture setting and zoom mode (A or M).

The flash output can be controlled by pressing the "+" and "-" buttons, the top limit is 1/4 in this case. No stroboscope exposures are possible with half or whole output of the 430 EZ. Press the **MULTI** (Hz) button to set the stroboscope frequency or the number of times the flash operates during 1 sec. Available are frequencies from one to ten flashes per second. Remember that the flash will only operate about three times when the flash output has been reduced to a quarter and the frequency set to 10 times per second.

As with the Speedlite 300 EZ flash synchronization for the second shutter blind is also a feature of the Speedlite 430 EZ. Normally the flash operates when the first blind has exposed the film completely. A subject moving through the viewfinder when a slow shutter

174

Canon Speedlite 430 EZ (front)

1 Rotating and swivelling flash head
2 Reflector for IR fill-in flash
3 AF Illuminator
4 Fixing pin
5 Sensor
6 Battery compartment
7 Connector for external power unit
8 Fixing wheel
9 Hot shoe contact

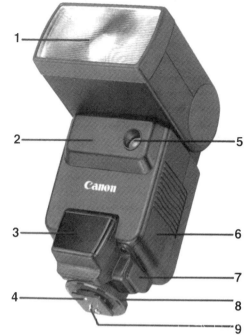

(back)

1 Flash head rotation release
2 LCD panel
3 Command Dial
4 Manual mode button
5 Ready light
6 Synchronization button for first and second blind
7 LCD panel illumination button
8 Manual zoom of reflector button
9 Main switch

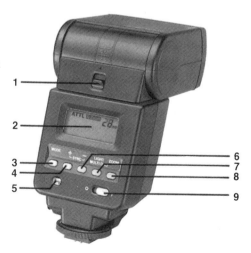

speed has been set, will first be frozen by the flash and then depicted blurred. The picture will not illustrate the dynamics very well. Slow synchronization for the second blind involves the flash operating just before the second blind moves.

As soon as the Speedlite 430 EZ is used separately from the EOS 10, synchronization is no longer possible. Also A-TTL metering will be reduced to normal TTL, fill-in flash is inoperative and the zoom reflector can only be operated by hand. The range of the flash cannot be displayed in manual operation and the AF Illuminator is inactive, too.

Is there then any reason to use the Speedlite 430 EZ separately from the camera? A separate flash can give better lighting when coming from above or from the side of the subject to imitate the sun at noon. Several separate flash units allow special effects in a home studio. To judge the light correctly prior to exposure the use of several household spotlights is useful.

A flash unit separated from the camera is connected to it by an adapter and a contact cable. A TTL hot shoe adapter is inserted into the accessory shoe of the camera and connected by one of the two cables (60cm and 3m long) to the TTL adapter holding the flash unit or to a TTL distributor plate. By means of the connection cords three external TTL hot shoe adapters and three flash units can be connected. As the accessory shoe of the camera can accommodate another flash, a total of four flash units can be controlled by the camera at the same time.

The EOS 10 will switch the flash off when the film has received sufficient light to record the picture - irrespective of the amount of light each unit has contributed to the total light. When one of the units is placed closer to the subject it will become the main light source while the others lighten the shadows and create different effects.